Painting Landscapes & Figures *In Pastel*

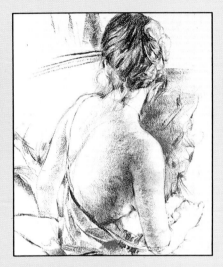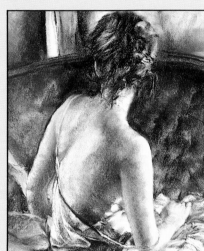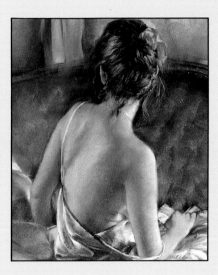

JOSE M. PARRAMON

Watson-Guptill Publications/New York

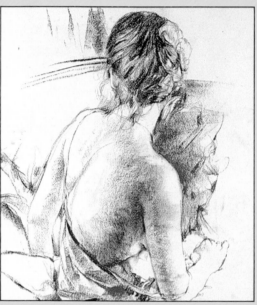

Copyright © 1989 by Parramón Ediciones, S.A.

First published in 1990 in the United States by Watson-Guptill
Publications, a division of BPI Communications, Inc.,
1515 Broadway, New York, New York 10036.

Library of Congress Cataloging-in-Publication Data

Parramón, José María.
 [Pintando paisaje y figura al pastel. English]
 Painting landscapes and figures in pastel / José M. Parramón.
 p. cm.—(Watson-Guptill painting library)
 Translation of: Pintando paisaje y figura al pastel.
 ISBN: 0-8230-1699-4 (paperback)
 1. Landscape in art. 2. Human figure in art. 3. Pastel drawing—Technique.
 I. Title. II. Series.
 NC880. P3413 1990
 741.2'35—dc20 90-12553
 CIP

Distributed in the United Kingdom by Phaidon Press Ltd.,
Musterlin House, Jordan Hill Road, Oxford OX2 8DP.

Manufactured in Spain
Legal Deposit: B-23.685-90

1 2 3 4 5 6 7 8 9 / 94 93 92 91 90

Painting
Landscapes & Figures *In Pastel*

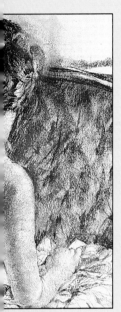
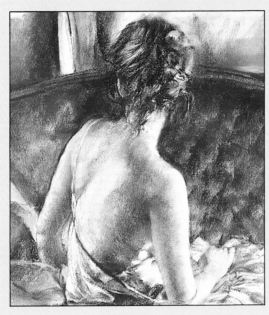
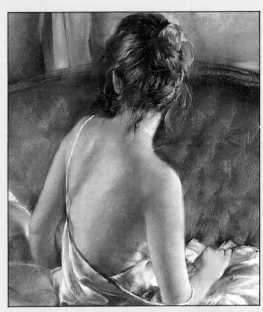

The Watson-Guptill Painting Library is a collection of books aimed at guiding the painting and drawing student through the works of several professional artists. Each book demonstrates the various techniques, materials, and procedures used to paint in specific mediums, such as watercolor, acrylic, pastel, colored pencil, oil, and so on. Each book also focuses on a specific theme: landscape, nature, still life, figure, portrait, seascape, and so on. There is an explanatory introduction in each book in the series followed by lessons in drawing or painting the specific subject matter. In the introduction of this book, you will start by looking at different styles of landscape and figure paintings in pastels; they are good examples of what you can hope to achieve in your work.

Perhaps the most extraordinary aspect of this book is the way in which the lessons (the choice of subject matter; the composition; the color interpretation and harmony; the effects of light and shade; and the technical knowledge and experience along with the secrets and tricks provided by several professional artists) are explained and illustrated line by line, brushstroke by brushstroke, step by step, with dozens of photographs taken while the artists were creating their paintings.

I personally directed this series with a team that I am proud of, and I honestly believe these books can really teach you how to paint.

José M. Parramón

Creativity, interpretation: style

In answer to the eternal question of what real art is—an imitation of nature or a work that rejects reality—the art theorist René Huyghe states that realism is but a mere vehicle that the artist uses to express himself.

In effect, any artist will quickly realize that merely copying what he sees is not satisfying. Instead, he will feel the need to appropriate or assimilate the model by adding, deleting, interpreting.... And thus the artist stops copying reality.

The verb "to interpret" means to modify, change, or transform reality. Eugène Delacroix, the famous French romantic painter, defined artistic interpretation in this way: "Reality is only one part of art, the artist's feeling completes it.... If you have really been moved by an object, you will transmit your emotion to it."

In order to interpret, the painter must educate his imagination, he must develop his creativity. *Theoretical* and *visual recollection* is very important in the artist's development of creativity: His art studies, the paintings by the masters that he has seen in art books or in museums, the beauty of a landscape he saw one day—all this constitutes a mental archive. The artist will search in his mental archive when using his creativity, to interpret the emotions that the subject stirs within him.

From interpretation and creativity, the artist will develop another concept: *style*.

The moment the artist combines the reality of the model with what he sees, he begins the process of *synthesis*—highlighting, reducing, deleting. It is through synthesizing that the artist develops a specific style. In short, style is the execution of the paint-

1

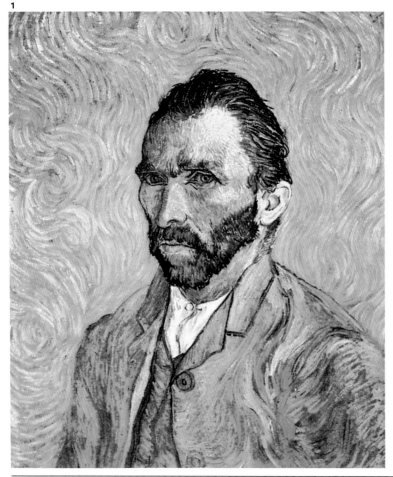

2

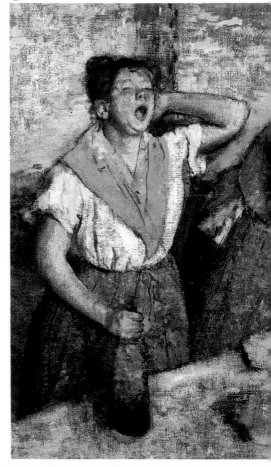

Figs. 1 to 3. From left to right: Van Gogh (1853-1890), *Self-portrait*, Rijksmuseum, Amsterdam; Edgar Degas (1834-1917), *The Ironers*, Orsay Museum, Paris; and also by Edgar Degas, *Woman Washing Her Left Arm*, Louvre Museum, Paris. Van Gogh, like many of the impressionists, broke away from the schemes and styles of academic painting, adopting new techniques and forms of painting never seen before. Degas maintained a certain relationship with the past in his oil painting style, but when he used pastels, his work manifested a new style that was both different and personal.

ing, the personal and unique mode of painting, or drawing a picture using a specific technique.

Interpretation, creativity, and style are concepts that have existed throughout the history of art. But it was the impressionists who broke with the constraints of academicism in classical art (viewed as the art of the past) and created new forms and styles of painting and drawing.

Van Gogh's style was, and is, so personal and different that many condemned his paintings as the work of a madman. The paintings by Degas were distinguished from other paintings of the time by their settings and compositions, which in part were influenced by Japanese woodcut illustrations that arrived in Paris in the middle of the nineteenth century. Degas's paintings were also different because of their loose lan-

guage, in spite of the fact that they still reflected the influence of the great masters, especially Ingres. But when Degas started painting and drawing with pastels, there was no longer any association with the past. He painted his pictures with pastels in a new style, testing and demonstrating the different possibilities they allowed.

In the following pages, you are going to see the wide range of creativity and style that pastels can offer.

3

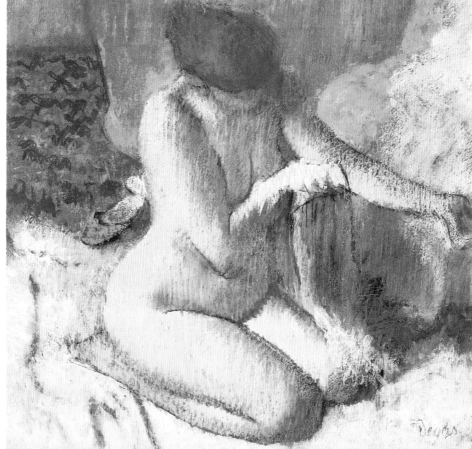

Drawing with three colors

The development of drawing has been associated with the evolution of materials, which has had a slow progress. For thousands of years, drawing supports consisted of parchment, limestone, or wooden boards, and the only drawing tool was charcoal. In fact, in the Paleolithic period, charcoal was used with a metallic point or stylus (forerunner of the lead pencil) to create cave paintings. The invention of paper that had taken place in China in the second century was not known in Europe until its introduction by the Arabs in A.D. 751.

Around 1390, a work by Cennino Cennini, *The Craftsman's Handbook*, was published in Italy. It constituted a precise historical document of the drawing procedures and materials that were used during that time, the very beginning of the Renaissance.

In his book, Cennini mentions that all the artists of his time—Giotto, Bellini, Cimabue, Botticelli—drew their rough sketches with coal before beginning their mural paintings. These rough sketches were called *cartoons*. Cennini also cites the use of white chalk to obtain highlights as well as the use of colored paper, including an explanation of the dyeing process. Cennini's contemporaries drew with three colors: black from charcoal, the color of the paper drawn on, and the white chalk used for the highlights.

In the latter part of the fifteenth century, Leonardo da Vinci mixed iron oxide with an agglutinated pigment and chalk from which came the drawing medium known as sanguine. Leonardo, Michelangelo, Raphael, and other great Renaissance masters drew with sanguine on colored paper, highlighting the bright areas with white chalk.

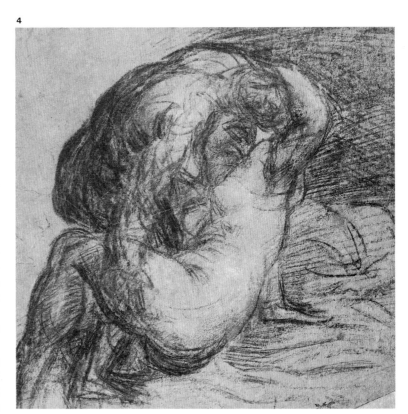

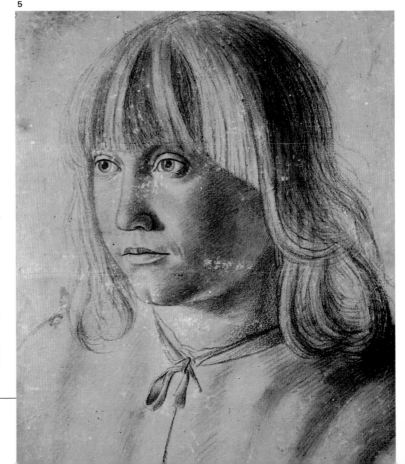

Figs. 4 and 5. Top: Titian (1487 or 1490-1576), *Jupiter and Io,* Fitzwilliam Museum, Cambridge; right: Antonello da Messina (1430-1479), *Portrait of a Young Man,* Albertina, Vienna. Two characteristic examples of drawings on colored paper, Titian's in charcoal and da Messina's in sanguine; both used white chalk for highlights.

6

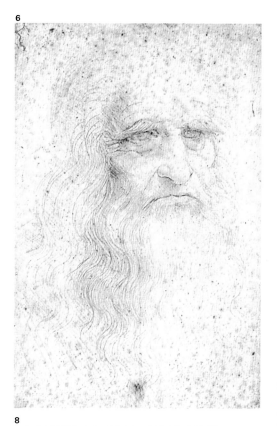

7

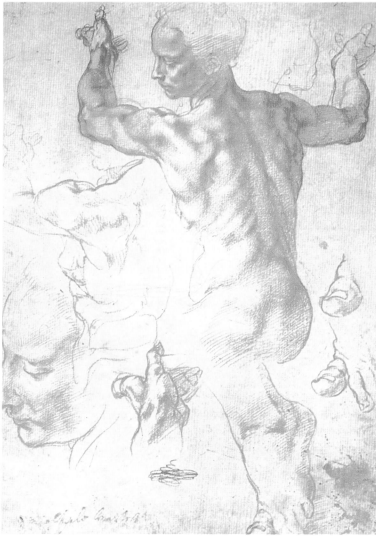

8

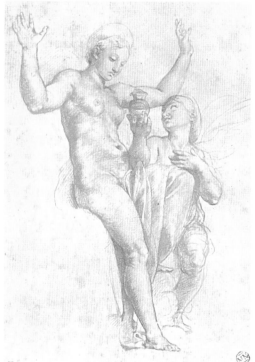

9

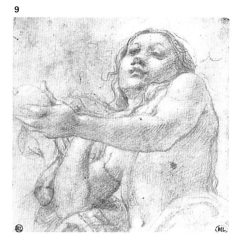

Figs. 6 to 9. Leonardo da Vinci (1452-1519), *Self-portrait,* Royal Library, Turin; Michelangelo (1475-1564), *Studies for the Libyan Sybil* (detail), Metropolitan Museum of Art, New York; Raphael (1483-1520), study for *Venus and Psyche,* Louvre Museum, Paris; Correggio (1489 or 1494-1534), *Eve,* Louvre Museum, Paris. Here are four magnificent examples of sanguine drawings on colored paper with white chalk highlights.

The first drawings painted with pastel colors

Finally, at the end of the year 1499, the first colored pastels appeared. They arrived in Italy by way of the French artist Jean Perréal, better known as the Master of Moulins. Perréal was traveling with the court of King Louis XII of France, when the King and his army invaded Milan. Perréal had been to Italy several times and knew Leonardo da Vinci. According to a note written by Leonardo in his *Codex Atlanticus* (sheet 247, Ambrosiana Library, Milan), da Vinci mentions that Perréal told him about "a new technique to paint with dry colors."

So it seems possible to affirm that in the sixteenth century, artists had colored pastels at hand, along with charcoals and black, white, gray, and sanguine-colored chalks; there was also a blue type of chalk that appeared in some works at the beginning of the sixteenth century.

Rubens was one of the great artists of the baroque period who most benefited from this new medium. Because his work as a diplomat required frequent travel abroad, Rubens trained artists in his studio, including such talents as van Dyck and Jordaens, to paint pictures based on sketches he himself drew using four colors: charcoal, sanguine, and white chalk on colored paper, with the occasional addition of gray and blue.

More than 2,005 paintings came out of Rubens's studio, most of them painted by his students, with Rubens intervening periodically to add the "most delicate" of details. Rubens himself did most of the preliminary color studies and drawings.

Even with the invention of "dry colors," most artists continued "painting" with colors while they were drawing. In France during the seventeenth and eighteenth centuries, the rococo style dealt with themes of the court and the well-to-do members of society of that time; these themes became known as *fêtes galantes*. Watteau, his disciple Boucher, and Fragonard, who at the same time was Boucher's student, were all painters of *fêtes galantes*. These three artists drew hundreds of studies of heads and hands for their pictures, using charcoal, sanguine, and white chalk. Their method of draw-painting with three colors became so widely used that it became known as *dessin à trois crayons*, and was spread throughout the world.

Fig. 10. Federico Barocci (1535-1612), *Head Profile* (detail), National Museum, Stockholm. In the sixteenth century, pictures were already being painted and drawn in sanguine and colored chalk on colored paper; this method developed into the idea of draw-painting.

Fig. 11. Jean Antoine Watteau (1684-1721), figure for *Spring*, Louvre Museum, Paris. In the eighteenth century, Watteau and his contemporaries Boucher and Fragonard established the *dessin à trois crayons* draw-painting style, using charcoal, sanguine, and white chalk on cream-colored paper.

10

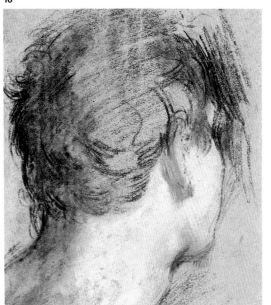

11

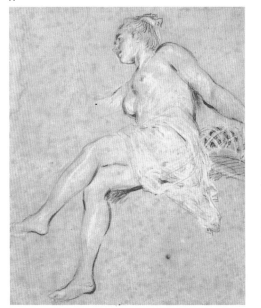

Fig. 12. Peter Paul Rubens (1577-1640), *Portrait of Susanna Fourment*, Albertina, Vienna. This portrait study is a good example of one of the pictures painted by Rubens with colored chalk, or the first pastel colors, basically using black, sanguine, dark sepia, blue, and white highlights on a cream-colored paper.

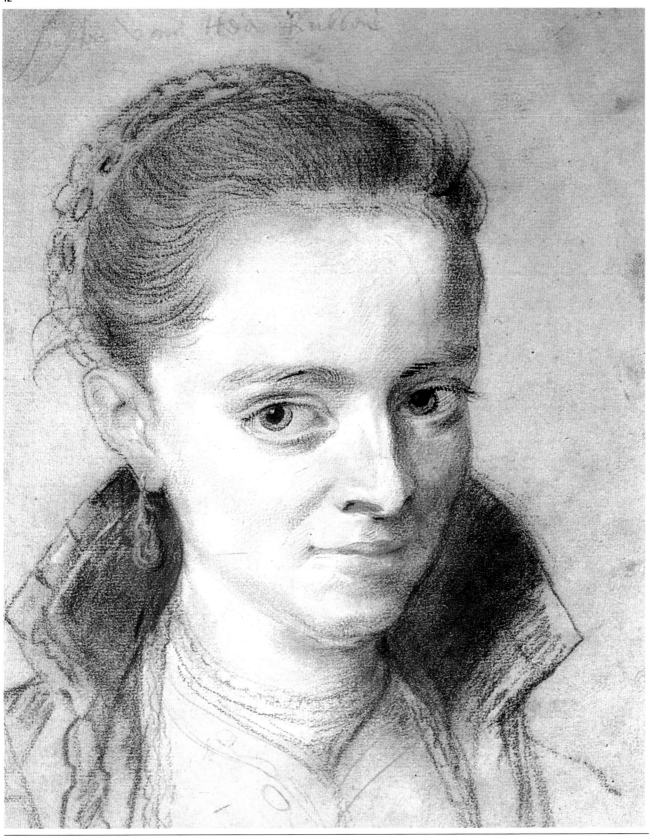

Painting with colored pastels

You will now learn about the characteristics of colored pastels.

The proportion of gum arabic that was used as a binder in the fabrication of the first colored pastels made them extremely fragile. This single characteristic distinguishes colored chalk from colored pastel. Colored chalk—derived from limestone and bound with gum, like white chalk with a pigment added—was by comparison to the first colored pastels a hard material that was well suited for drawing.

In fact, the first pastel paintings accentuated the same pictorial possibilities achieved with oils. Because of the fragility of the early pastels, artists of that time could do intense stumpings to create blended and diverse effects, which were similar to effects produced with oils.

In the portraits by the Venetian Rosalba Carriera (1675-1758) and the French artists Maurice Quentin de la Tour (1704-1788) and Jean-Baptiste Perronneau (1715-1783), the surfaces appear full of color and the finishes show a rich fusion so perfect that they could be easily confused with oil paintings.

As a result pastel became the prime and eminent medium for painting in that epoch. It reached such a point that many artists who had painted most of their works in oil started experimenting seriously with pastel *painting*. Such was the case of Jean-Baptiste Siméon Chardin (1699-1779), an important French still-life oil painter. He is also noted for a portrait of his wife, which is considered one of the best pastel paintings of the eighteenth century.

However, the use of charcoal, sanguine, and white and colored chalk did not diminish during the eighteenth century. Artists continued to use them for drawing outlines and sketches that were later painted in oil. This led some artists to paint with pastels in a new manner, a distinct way of working that did not involve trying to fill the whole picture by stumping and blending colors. Instead, some artists began draw-painting the model in a more linear style.

Degas became the master of this style.

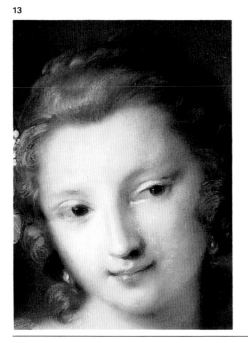

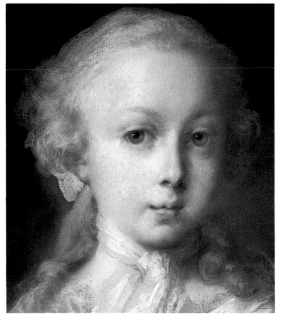

Figs. 13 to 18. Rosalba Carriera (1675-1757), details of *Allegory of Painting* (left) and *Adolescent of the Leblond House* (right); Maurice Quentin de la Tour (1704-1788), *Monsieur Duval de l'Epinoy*, Calouste Gulbenkian Museum, Lisbon; Jean-Etienne Liotard (1702-1789), *Portrait of Mademoiselle Lavergne*, Rijksmuseum, Amsterdam; Maurice Quentin de la Tour, *Self-portrait*, Chicago Art Institute; and Jean-Baptiste Siméon Chardin (1699-1779), *Portrait of His Wife*. In the eighteenth century, pastel colors were used as a medium for painting. The artists of that time painted with pastels in a style that was often confused with oils.

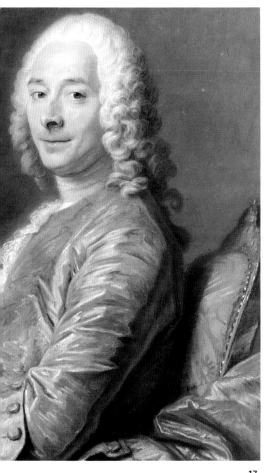

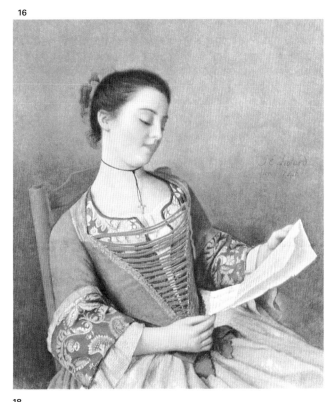

16

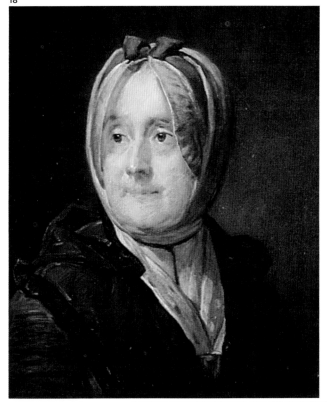

18

17

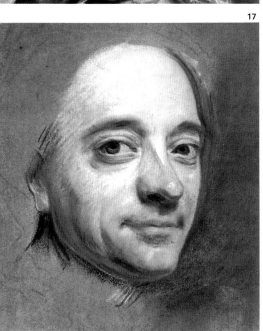

Technique and styles of pastel painting

When working with pastels, Degas first made a precise drawing, sometimes with chalk, and other times with pastel. Then he painted, without stumping, leaving visible sketch lines to indicate the natural direction of the subject. Forms were defined with freely drawn sketch lines that were surprisingly vertical in some cases. Degas demonstrated his independence and personality through his paintings and thus produced an unmistakable style.

Pastels have been used by the great masters to create paintings, or what have become known as drawing-paintings. However, the question is not about the pre-eminence of either technique, but about the justified coexistence of the two of them together, allowing two styles of pastel painting as well as a third style: the two techniques mixed together.

By looking at the reproductions of pastel paintings on the following pages, you can see the possibilities of adapting colored pastels to diverse styles. These possibilities can be achieved in the following ways.

1. Stumping the color over the entire surface of the picture, similar to color mixing in oil painting, thus obtaining an oil painting finish.
2. Resolution of the work without stumping the colors, allowing the sketch lines and texture of the paper to be seen in a draw-painting style.
3. A mixed style, in which there are stumped areas with lines drawn on top of them, next to an almost perfect finish, drawn or painted.

I hope that this introduction and the following pages of step-by-step examples of pastel pictures will help you perfect your technique and style when drawing and painting in pastels.

19

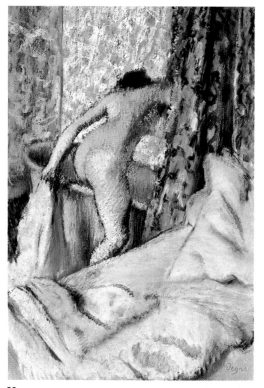

20

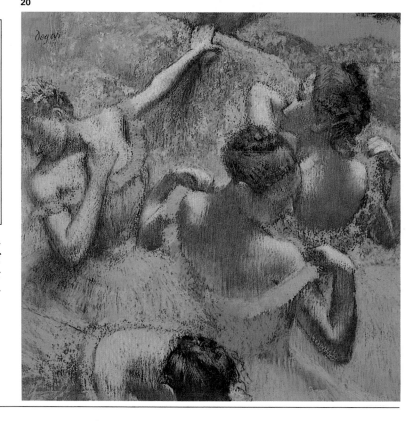

Figs. 19 to 21. Edgar Degas (1834-1917), *The Afternoon Bath*, Chicago Art Institute; *Blue Dancers* (detail), Pushkin Museum of Fine Arts, Moscow; *Before the Exam*, Art Museum, Denver. Edgar Degas was blind when he died at the age of eighty-three. From the age of sixty, he painted more pastel paintings than oil paintings. He liked to experiment with colors, solvents, liquid fixatives, and so on. Through experimentation, Degas developed his painting style with pastel colors. In the two works on this page (left and below), you can see Degas's style of painting with visible lines, showing the pastel strokes and the texture of the paper. In the painting on the following page, you can appreciate a mixed technique, with more or less finished stumped areas that have lines drawn on top of them—a characteristic style of Degas.

21

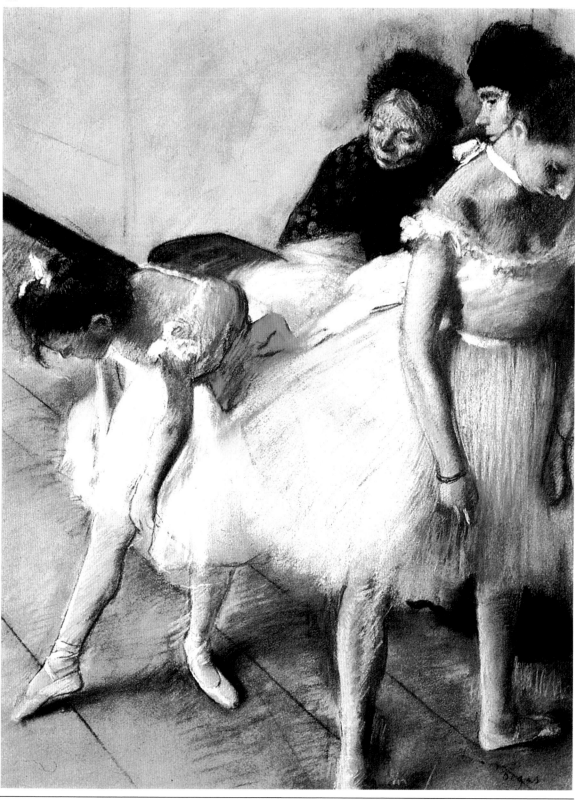

Olmedo, graphic designer and painter

ing a color he doesn't have to mix different brands of pastels.

"Of course, for the colors to stick, I use my fingers. It is the grease of the fingers, or human skin, that makes the colors stick to the paper. When other tools are used, such as a stumping pencil or rag, a great deal of the color is removed with them."

Fig. 22. Salvador González Olmedo, a painter and graphic designer, specializes in pastel painting and has been in several exhibitions, in which he has won prizes for his landscapes and seascapes.

Figs. 23 and 24. Here are two views of Olmedo's painting studio. In the bottom photograph is an easel with a sheet of ochre-colored paper attached to it. On the ledge is a color pastel ''palette'' made up of a tray with compartments, in which you can see sticks and stubs of pastels; everything is set up for the painter to begin painting.

You should begin this section by imagining that you are in Salvador González Olmedo's studio. In the art world, he is simply known as Olmedo.

Since Olmedo has two professions which are closely related, he also has two studios in his rather small house. In the studio facing north, he carries out his publishing work, and in the studio facing south, he paints.

Olmedo's painting studio is flooded with direct sunlight from early morning on. "It is better to paint with natural light," the artist says, "but if necessary, I can also paint under artificial light."

Olmedo has exhibitions regularly, in various places up and down the coast of Spain in the area around Barcelona, where he lives. He believes it is easier for him to sell his paintings than for other painters in the area because he works with pastels while many of the other artists paint with oils.

"Like many artists, I've painted with many different materials, using various techniques. I recognize that oil is 'the king' of all procedures, but for me pastel allows even more spontaneity than painting with oil."

The pastels

As for quality, Olmedo prefers the softest color pastels. He also works with one brand of pastels that is manufactured in a wide range of colors, so when he is lack-

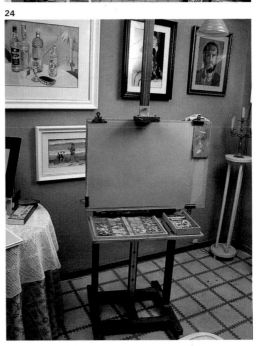

Olmedo's "palette" of pastel colors

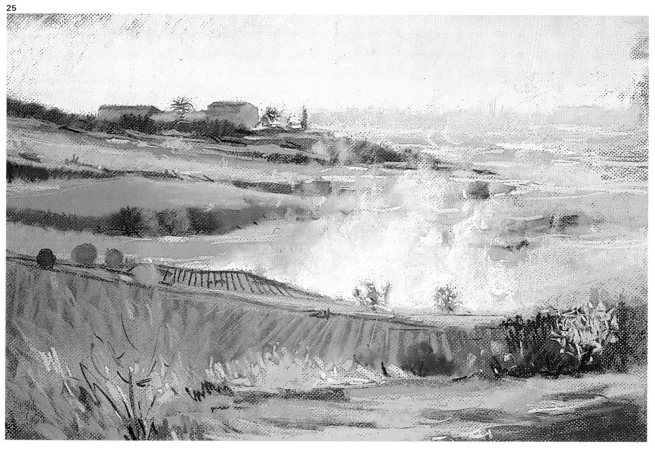

Fig. 25. This is a magnificent example of Olmedo's artistic abilities as a landscape pastelist a landscape that has spontaneity and energy as well as a perfect composition, a good drawing that is characteristic of Olmedo.

It could be said that pastel painting, more than any other medium, is essentially manual painting, meaning it is done with the fingers. In oil painting, the fingers help the brush, but in pastel painting, where brushes aren't used, the fingers are everything.

When Olmedo begins to paint, he has in front of him a wide spectrum of colors, distributed in the following way: first the blues and violets; then the greens and yellows; in the third compartment there are reds, oranges, and warm tones; and finally the tones that make up the flesh and dark earth colors. The artist also has a series of stumps and left over pastel pieces that can be useful for adding a highlight to some detail of the picture. It is best to keep these pieces on the far side of what you will call your palette (fig. 26).

Fig. 26. Here, you see the color "palette" used by Olmedo. "In order to make the color selection easier," Olmedo explains, "I classify hues by range—on the left the cool colors, on the right the warm ones, and next to them the flesh colors. The rectangular compartment on the far right-hand side contains stubs and small pieces of pastels."

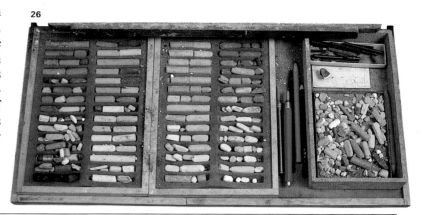

Colored pastel and paper

Pastel sticks measure about 2¾ inches (7 cm) in length, but as Olmedo says, "like all pastelists," he cuts the sticks in half (fig. 27). When the pastel stick is halved to about 1½ inches (3.5 cm), it becomes a good length to quickly spread the pastel color over large areas of the paper. Some pastel manufacturers have foreseen this and have made 1½ inch (3.5 cm) sticks as well as the full size ones.

To complement the standard size pastels, Olmedo also uses pastels that come in rectangular-shaped sticks. These types of pastels are more compact and have more contact with the paper. They are used mainly to define details, since they cannot be applied as easily with the fingers as normal pastels.

Olmedo also has a collection of pastel pencils. They look almost identical to ordinary colored pencils, but they have pastel points. Pastel pencils can also serve as a complement to pastel sticks, for painting profiles and small details (fig. 28).

In the color range of pastel sticks that Olmedo uses there are 163 colors. The widest choice on the market has 336 colors, but there are also smaller selections made especially for painting portraits, figures or landscapes. All brands supply replacement colors.

The paper

Olmedo always works with Canson paper in two sizes, 19"×25" (50×65 cm) or the double sized 39"×51" (100×130 cm). This paper is manufactured in different colors and your choice will depend on the theme you are going to paint. For example, Olmedo says for a figure he usually uses the brown or beige and for a seascape a gray (fig. 29). He never works on white paper because gray or any other neutral tone— brown, blue, pale blue—work for him, that

27

Fig. 27. Olmedo, like many artists who paint in pastel, breaks his sticks into two or three pieces. By halving the pastels, he is able to use them in the two most basic ways: drawing with the point or using the flat side of the stick as you can see in figure 46 on page 21.

28

is to say, they help him deal with the problems of color harmonization. "By using white you are starting from zero," he concludes.

Some painters use a separate piece of paper as a palette in order to test color mixtures, but Olmedo uses the actual paper he is painting on. With a ruler, he carefully draws margins and designates those areas for mixing colors (fig. 30).

He also has a piece of sandpaper at hand, placed on the extreme right of the easel. The sandpaper serves as a "sharpener" for the pastels. "But I hardly ever use it," he says.

Fig. 28. Pastel pencils are valuable tools for pastel painting; they allow the artist to produce fine strokes and apply small details more easily.

When he is painting a landscape, Olmedo almost always works with a motif from nature. Sometimes he goes out with a limited selection of hues and takes notes (fig. 31). On other occasions, he takes photographs to recall the scene in the studio.

Fig. 29. Colored paper is usually used for pastel painting. The best paper for pastels is Canson, which comes in a wide selection of tones and colors. Take note: This kind of paper has two sides, one more textured than the other; but the paper does not have a "wrong" or "right" side. Both sides can be painted on, depending on your personal preference.

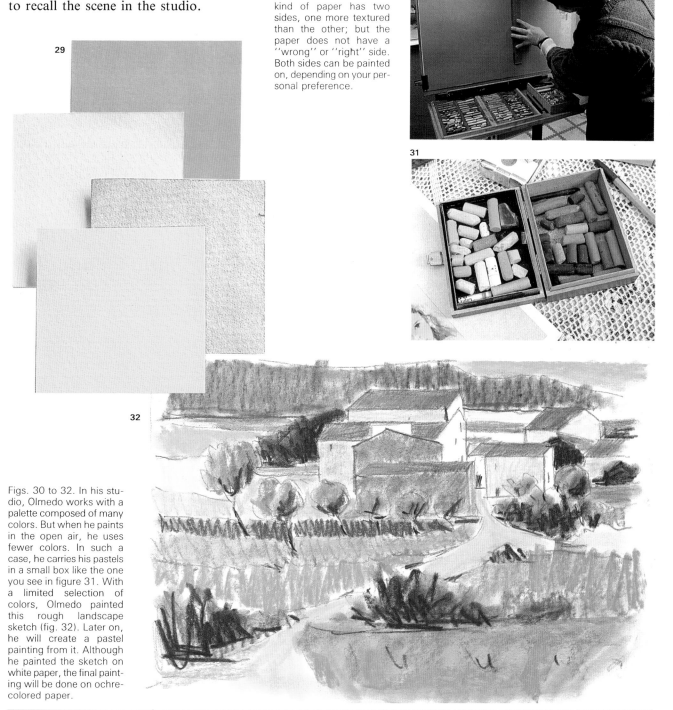

29

30

31

32

Figs. 30 to 32. In his studio, Olmedo works with a palette composed of many colors. But when he paints in the open air, he uses fewer colors. In such a case, he carries his pastels in a small box like the one you see in figure 31. With a limited selection of colors, Olmedo painted this rough landscape sketch (fig. 32). Later on, he will create a pastel painting from it. Although he painted the sketch on white paper, the final painting will be done on ochre-colored paper.

First stage: drawing in sanguine

33

After Olmedo draws rules for the margins, he proceeds to outline his composition on a sheet of brown paper. He will have to use a tone somewhat darker than the color of the paper for it to be visible. "But not too intense, for the moment," Olmedo says. In the initial stage, he prefers the contrast between the paper and the drawing to be minimal. It is best to use a brown or sanguine color. Olmedo goes for the sanguine.

34

35

The artist uses the sanguine with great precision, without haste, clearly outlining the main volumes (fig. 33). Some painters who are not as meticulous as Olmedo might say that the drawing is an "architectonic" drawing because of its light shades. But Olmedo never seems to worry about such critics: He just continues to sketch.

"Landscapes present fewer problems than figures," he says, "because if there is an error in proportions you do not notice it as much. The relationship between a tree and a house does not have to be as accurate as the relationship between an arm and a head. In a figure, you notice the errors right away. For this reason, there are fewer figure painters than landscape painters, simply because it is far easier to paint landscapes."

Olmedo also says that his goal is to be a figure painter, for the very reason that there are more difficulties involved, which for him is more stimulating. But for the moment, he will continue outlining his landscape in sanguine.

Second stage: reinforcing the initial drawing

36

Figs. 36 to 38. Olmedo continues to work on the initial drawing in sanguine, and then redraws the sketch with a darker color (burnt umber) that makes the composition more visible and precise.

Fig. 39. In the initial construction of the drawing, it is not necessary to include all the small details of the subject. It is sufficient to draw in synthesis, outlining the forms.

Eugenio d'Ors once said that things are seen better when they are darkened. Olmedo seems to agree with the Spanish thinker, for now he takes up a burnt umber chalk pencil that has a consistency similar to that of a hard pastel. He starts to go over the initial drawing, touching up the sanguine sketch (fig. 38).

The picture now looks more "constructed" than in the previous stage with the sanguine. This method cannot be done in watercolor. Pastel is more like oil than watercolor, because you can start with a darker color scheme without impeding any lighter tones that might be added on later. The one advantage it does have over oil is that it does not need time to dry.

37

38

39

Third stage: coloring

After Olmedo finishes his drawing, he colors a small area in the central left-hand part of the picture with an orange-ochre color. Directly after that he uses a sanguine tone pastel to color the lower part of the picture, which is the foreground (fig. 41). He spreads the color with the flat part of the pastel stick. By halving the pastel stick to a length of 1½ inches (3.5 cm), he can easily cover an area completely with color, in an energetic and spontaneous manner.

Contrary to what watercolor painters do, pastelists can start coloring specific areas, such as the lower middle part of this picture, which will later be the foreground; a foreground that perhaps in the end will have less relief than the houses in the background. As Corot once said, and perhaps Olmedo keeps it in his mind unconsciously, relief can be obtained with a stumping process in the foreground and a stronger focus on the subsequent planes.

The same effect is obtained by certain photographers and cinematographers when they try to focus on two subjects in the center of the screen; everything in front of the subjects is then out of focus.

While working, a pastelist usually holds the pastel sticks he is using for that painting in his free hand, in a "beggar" position. The hand with the pastels becomes a supplementary palette (fig. 42).

In this phase, Olmedo is coloring large areas of the picture, reserving only the shapes of the houses. There is red in the foreground, green in the background, different greens in the central part, ivory in the paths, and areas of orange, ochre, and a little sienna. In the small areas he experiments with a mix of various tones, which he then stumps with his little finger. But the large patches of color in the picture have not yet been blended; they are made up of thick

40

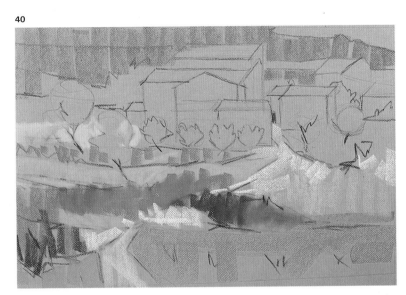

strokes applied directly with the pastel stick. It is basically a drawing done with thick colored pencils. But the unique painterly quality of pastels is already apparent.

41

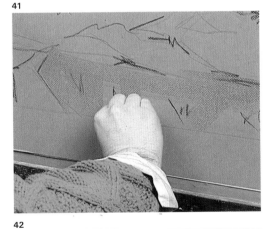

42

Figs. 40 and 41. In this stage, you can see that Olmedo has started to paint color all over the picture with veritcal strokes, using the flat side of a pastel stub.

Fig. 42. When an artist paints in a specific color range, he usually holds the pastels in the opposite hand to the one he is painting with, thus facilitating rapid execution.

Fourth stage: creating contrasts

Olmedo now starts to create strong color contrasts. Using a broken white, he colors in the lighter areas, such as the facades of the houses, until all the light zones are established.

In this stage, the little finger is used more and more. In spontaneous action, Olmedo spreads the color of the pastel stick and immediately starts stumping with his finger (figs. 44 and 45). Now and then he cleans his finger in the margins of the paper.

Somehow, the contrasts created by the white of the houses give the same effect as the white of the tutus in Degas's paintings of dancers. You can imagine that perhaps this is how the great pastelist painted his famous pictures of dancers: spreading the color with the pastel stick and immediately stumping with his little finger.

In the shadowy parts of the houses, Olmedo has already added a mauve color—a color in the violet range. As you can see, the main color elements have been painted in, along with yellow ochre on the extreme top right and red on the roofs of the houses. Now the painter is enjoying the painting.

Take note of the mauve tone in the central facade: It is not uniform, it is blended in its middle area with a diffuse patch, which is lighter and pinker. Also notice how the large extension of reddish earth in the right-hand part of the foreground has ochre blended into it. Olmedo mixed and spread the color with his fingers.

43
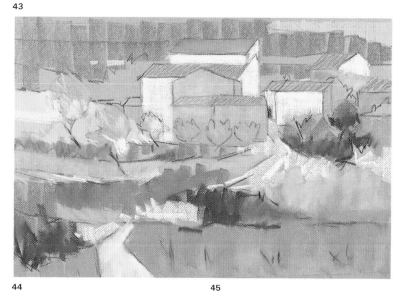

44
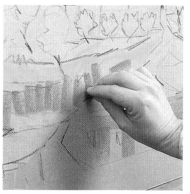

45
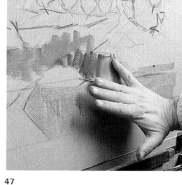

46
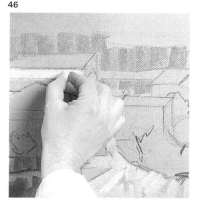

47
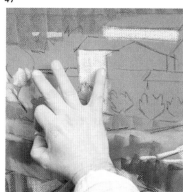

Fig. 43. The fourth stage shows the general coloring. The background color of the paper is practically eliminated, and you can see the general color harmonization of the theme.

Figs. 44 to 47. Applying strokes and blending... more strokes and stumping... blending... and now and again he leaves a visible line without blending it. This pastel technique is explained better with photographs than with words.

Fifth stage: more fingers all the time

48

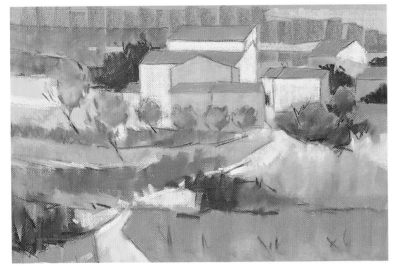

49

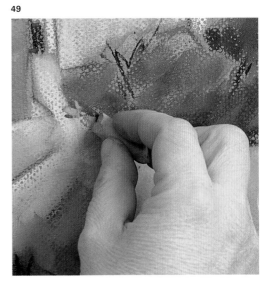

As a pastel painting progresses, the artist has to use his fingers more and more, especially his little and ring fingers, as well as the palm of his working hand.

For example, the color of the roofs of the houses were spread with the artist's fingers. The small group of six trees in front of the houses are also full of color that has been touched up. But more than anything else, the painting has been intensified with the introduction of a dark green, a key tone in this landscape. Notice the large green patch behind the last house on the left, and the three smaller patches among the houses on the far right.

Sometimes a painter will add color to a patch that has already been painted. In such a case, he will immediately begin to mix the colors with his fingers. For example, a green can be modified by introducing another color onto it. You can lighten or darken a color by adding and blending in another tone.

"The key to painting in pastel," Olmedo states while he continues to paint with his fingers, "is in the artist's ability to make the painting appear soft and energetic at the same time. Soft without being bland and energetic without being too hard. In order to achieve this, it is a matter of combining the stumping tones adequately with the drawn lines. Sometimes it is necessary to add colors that are nonexistent in the subject matter—colors that are imagined by the painter, who introduces them into the painting to enrich the contrasts."

Having said that, Olmedo puts his words into action by adding a daring stroke of blue into the brushwood at the lower left-hand side of the picture. Note the carefree attitude of this stroke.

In pastel painting, it is sometimes necessary to *blur* the strokes in order to eliminate the excessive rigidity produced by them. It is exactly what Olmedo proposes to do now, but without haste; he works step by step, so he can enrich the details without losing any of the overall harmony.

In one instance, Olmedo literally breaks the pastel stick onto a specific part of the picture, where fragments of the pure pastel remain on the surface, creating a unique impasto effect (see detail in fig. 49).

Fig. 48. If you compare this stage with the previous one, you cannot really say that the picture has changed much. Nevertheless, it is in a more advanced state. Olmedo is following Ingres's standard of "doing everything at once, advancing the painting's progress at the same time."

Fig. 49. Because pastel colors are opaque, you can paint light pastel colors over dark ones. At times, the forceful energy used to paint a light color over a dark one may cause the tip of the pastel stick to break onto the surface, creating a vibrant impasto, as you can see in this photograph.

Sixth stage: subtlety

50

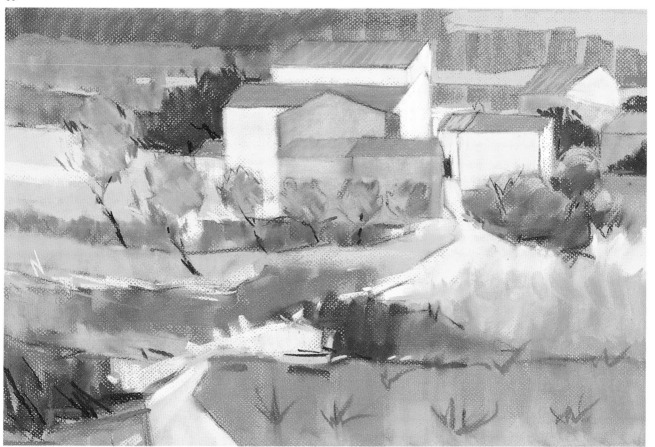

Fig. 50. In the large reproduction, you can see the execution and the texture of this pastel painting—the intensity of light colors covering darker ones, the energy and spontaneity with which Olmedo has rendered this landscape. Also notice how conducive pastel is for mixing colors. By applying and blending one color on top of another, you can create a series of new colors and tones to enrich the painting.

Subtlety is the word for this stage, because in reality the differences between this phase and the previous stage are not that great.

In this stage, Olmedo makes some interesting discoveries, some of them quite by coincidence.

"Do not be afraid of using your fingers to rub over parts of the painting you might have considered finished," Olmedo says. He continues by adding, "Such an action helps to spread the color, thus making the painting less rigid. For example, in the above painting, I rubbed the areas of the central buildings to create a contrast with the structure as a whole; otherwise they would be excessively rigid."

Look closely at the buildings. Do all the "white" parts of the houses look the same? At one point they were. Olmedo had painted all the houses with the same bone-colored tone. Now the houses are tinged with differ-

ent colors. One has been slightly dirtied with green and another with ochre, one is whiter than it was originally and another has changed from mauve to white. "It is not very convincing to think that all the facades were painted on the same day, by the same artist, using basically only one color," Olmedo says, smiling.

Olmedo goes on to say there are two basic schools of pastelists: those who do everything by stumping, and those who paint with strokes, without stumping. Then there is a third school, to which Olmedo claims to subscribe, which is a mixture of the two schools: those who stump but leave clean strokes, what you might call visible pastel "brushstrokes."

Seventh and final stage: refining and touching up

The moment has arrived for the artist to distance himself from his painting; he gets up and contemplates his work at a distance of about 10 feet (3 m). He wants to see the painting as a whole, and not lose himself in detail, to see if its equilibrium is exactly as he wants it to be.

But there are still many details missing (the houses have no windows, for example). Olmedo still has quite a lot of work before him. And as he adds the last touches, he always contemplates the work as a whole.

Notice, for example, how insufficient the green and yellow stumping is in the upper part of the picture. The strokes made with the pastel sticks can easily be detected, which makes them seem excessively disproportionate to the rest of the painting. The viewer gets distracted by this section because it lacks relief and depth, especially in the central area.

Olmedo starts blending the color with his fingers.

But let's go to the most important matter: refining the buildings.

Olmedo is able to "erase" the visible drawn lines by applying a lighter color on top of them. In this case, he applies a reddish-orange, or simply covers the lines with a broken white (don't forget that the color of the facade is a dirty, impure white).

Another rigid detail is the mauve-colored central facade, which is still too clean in spite of the pinkish stumping in the middle.

Olmedo resolves this difficult situation by dividing the facade into two with a vertical line running down the middle—using a hardly noticeable sienna—making one part more luminous. Perhaps some of the architectural logic is lost, but without a doubt, some vibration is gained.

Is the painting finished? The Spanish superrealist painter Antonio López has said that none of his paintings are ever finished: "When there is a formula to do things, it is obvious when you have finished them. But when you do not know what you are looking for, you only guess. You never finish the painting."

On the following day, Olmedo decides that the painting can be improved. Starting with the upper left-hand part, he decides to mix the ochre area with green, to eliminate any obvious separation between the two areas. Directly under this area, he introduces a generous touch of mauve, and the dirty green that was underneath what is now mauve becomes ochre. The mixing noticeably improves the green/ochre relationship of this section—it has given it more life.

Olmedo continues going further down the left-hand side of the painting. There is a section with energetic vertical strokes resembling blades of grass that separate the ochre from the green, and some strong sanguine lines in the weeds in the lower left-hand corner.

Take note of the buildings: The color modifications that have been added are subtle but important.

There are also new patches of gray and white in the building area. Olmedo decides to stop here, remembering a poem by Juan Ramón Jiménez: "Do not touch it any more,/the rose is like that."

One of your last questions may be: Does a pastel painting have to be fixed? It can be done with the same fixative used for pencil or charcoal. But Olmedo does not use a fixative because it often stains the painting, usually in the areas where the pastel application is the thinnest.

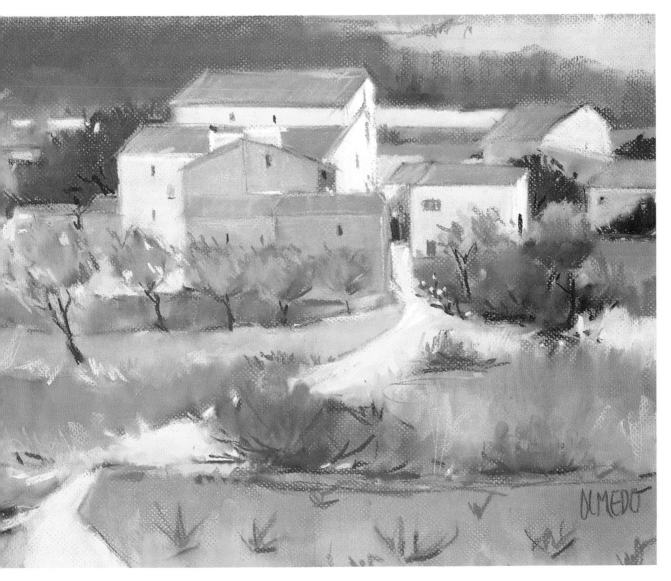

Fig. 51. This is the final picture. Olmedo has created a fine landscape painting with pastel. Observe and compare this last stage with the previous ones: Check the final tone and shade adjustments in the roofs, the walls, the earth-colored fields, and the green areas. Olmedo has also improved the composition, emphasizing specific areas of the landscape. For example, in the background and foreground he has decided to unify the color by highlighting it in the center. He has also softened the contrast of the forms and colors, thus improving the unity within the variety, which according to Plato is a basic rule for composing art. The finished painting has accentuated atmospheric highlights, which Olmedo achieved by blending the forms and the colors—particularly in the edges of the houses and the roofs.

The artist, the studio, the lighting

Our guest Mary Franquet is a young artist who specializes in drawing and painting portraits and figures with pastel. She studied fine arts and has had notable success in selling her paintings at exhibitions. Franquet started her career in art painting in oil, later discovering pastel. "I like to draw," she says. "I believe that pastel is the medium that allows me to draw-paint. But moreover, pastel provides me with an extremely wide range of colors with which it is possible to achieve every shade and contrast imaginable."

Franquet's studio is located in her apartment on the second floor of a building in an old quarter of the city. The apartment boasts a coffered ceiling, typical of the buildings constructed at the beginning of the twentieth century. The artist works in a room about $16\frac{1}{2} \times 19\frac{1}{2}'$ (5 × 6 m) in dimension, with paintings and sketches hung on the walls, which are painted salmon pink. This color happens to be one of her preferences, and she regularly uses it in her pictures.

Franquet generally paints with a model, whether in daylight or artificial light, which she will be doing now. The model is illuminated with a standard lamp with a spotlight, a 100-watt tungsten bulb. The lamp is situated at a 45° angle, in a frontal-lateral direction to the model. This way the face and figure are well illuminated, but at the same time allowing for a slight shady-light effect on the cheeks, the lower part of the nose, the lips, and so on.

To imitate natural daylight conditions, Mary also works with a fluorescent lamp with corrected lighting.

Fig. 53. In Franquet's studio, located in her apartment in the old quarter of the city, the walls are salmon-colored, a background color that Mary uses in many of her paintings.

Figs. 54 and 55. In these photographs you can see the model and the type of lighting that Mary uses: a neutralized fluorescent lamp, imitating natural daylight; and a spotlight giving frontal-lateral light from above.

52

53

55

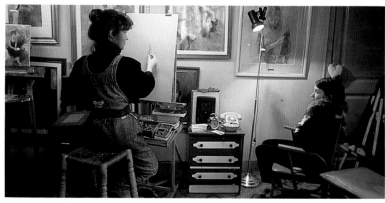

54

Fig. 52. This is Mary Franquet, the young painter, who for a long period of time painted in oil and who now paints exclusively in pastel. She specializes in portraits and figures and has won many prizes for her work.

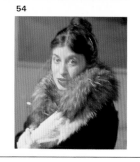

How Mary Franquet paints

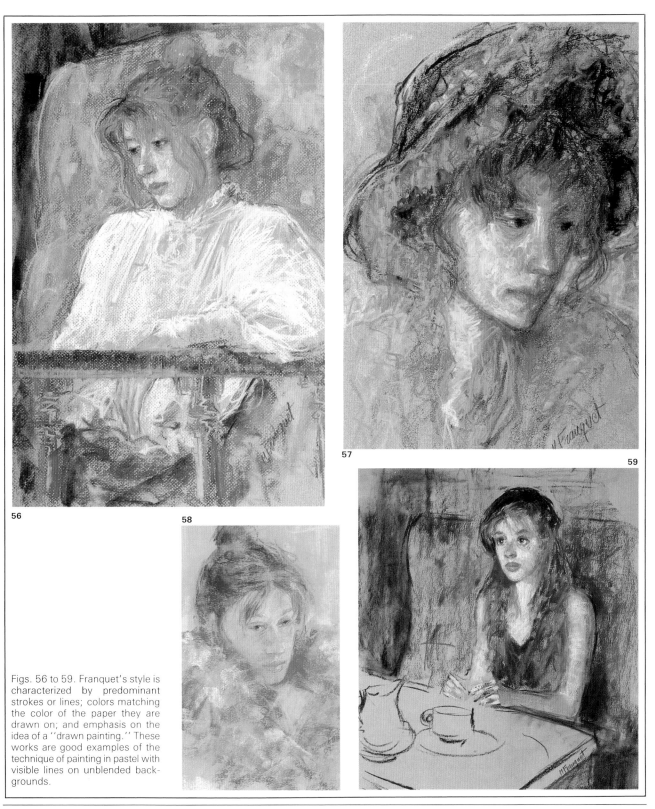

57

59

56

58

Figs. 56 to 59. Franquet's style is characterized by predominant strokes or lines; colors matching the color of the paper they are drawn on; and emphasis on the idea of a "drawn painting." These works are good examples of the technique of painting in pastel with visible lines on unblended backgrounds.

The materials

60

As you can see, Franquet and the model are ready to begin work (fig. 60). I should point out that Franquet's easel was custom-made for her. It is a special structure that has a wooden board to support both canvas or drawing paper, and it also has shelf type trays positioned in front. From the photograph, you can see that Franquet's palette is made up of many pastel pieces, all classified in two small boxes but without any chromatic division between warm and cool colors.

"I know how and where I put my colors," says Franquet, "and although order and method are not my best qualities, I know what color I want and find it when I need it."

You could say that Franquet works with a selection of colors that she has determined through her past painting experiences. I will conclude by telling you that Franquet uses an unknown brand of paper that is sold to her by an art school. In this case, it is a thick-grained gray paper, which is sized, giving it a hard grain. This paper is excellent for painting in pastel, especially in the style and manner that is characteristic of Mary Franquet—a free style with visible strokes that brings to mind the painting of Toulouse-Lautrec, whose work Franquet has always admired.

61

62

63

Figs. 60 to 63. In these four photographs, you can see Franquet in her studio, in front of her easel, with the model in the background; a custom-made easel with a tray for the pastels; a thick gray paper used especially for pastel painting; and the artist's trays of pastels.

First stage: the drawing itself

Franquet starts her drawing by making a linear composition with a sepia-colored Koh-i-noor pastel pencil. She looks at the model attentively, draws a few lines, returns to the model, then back to the paper to draw some more. It is a constant state of coming and going, while the model—dressed in black trousers and jacket, a fur stole, and white gloves—remains as still as a statue in a wax museum.

While Franquet is drawing, I stand next to her, dictating my notes for this chapter out loud to her. There is also a photographer and his assistant present, who will capture the progress of the painting, step by step. "Does it bother or worry you to have people around while you paint?" I ask. Franquet turns her head, smiles, and says, "No, I'm not exactly an extrovert, but I am accustomed to others seeing what I am doing, and it doesn't worry me greatly."

Franquet continues to draw. She discontinues a stroke, yet it maintains a continuity with the other lines. Starting with a rough guess, the artist reinforces it by drawing rapidly and concentrating clearly on her work. Now and then she takes a quick glance at the model. Once in a while she moves back in order to observe her work at a distance; looking at it as a whole, she doesn't stop to check small details. Next, she draws the eyes, nose, and mouth, then works on the hands, and finally the general profile of the body.

Figs. 64 to 66. Franquet starts constructing the figure by drawing with a soft carbon pencil. She sketches the model's facial features with great care, then draws the rest of the body with a few simple lines. With this simple drawing, she can begin painting the face.

64

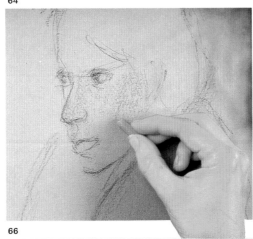

66

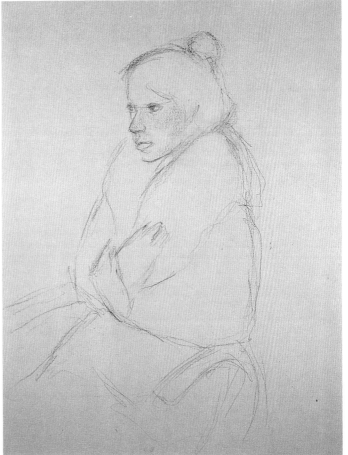

65

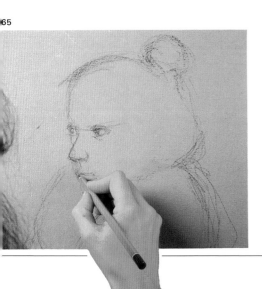

Second stage: general color application

Now Franquet begins to reinforce the outlines that make up the face, the eyes and the profile of the nose. She stops for a moment to perfect the form of the eyes and starts to paint the face with a pink salmon shade, mixing it with a light pink. She paints the lips in red. Then, suddenly she works on the hair color, painting that area with a stub of English red. With the pastel stick edgeways, half flat, she draws and paints with strokes that define the hairstyle and unite the form (fig. 68). Still using the same English red, she reinforces the rosy cheeks, goes back to the hair, and then reinforces the jawbone profile. Finished with the red for now, she picks up a dark burnt umber and paints it into the hair area, mixing it with the English red, painting, and making concrete forms.

In her left hand, she holds several stubs: a light pink, a dark sienna, an English red, and a light salmon. She uses all of them, alternating the colors while she thinks, looking at the model, painting a little, studying the model, and then working on the painting. This is a real show! If I could film what Franquet is doing while she is painting, you would see a restless hand making strokes without stopping, and taking them away just as quickly. It seems as if she were rehearsing the strokes: going up and down, stumping rapid touches with her fingers, reinforcing lines in a continuous movement. You would also see Franquet's head looking back and forth between the painting and the model, checking, painting, then checking again. All in all it is a true spectacle!

When Franquet "comes out" of this state of creative fervor, I daringly ask her:

"Do you always start with the face?"

"Yes," she replies, "the face is important for me; if I see it emerging from the beginning, I can continue with more enthusiasm and security."

"Well, Mary, the model's hair is brown, but you are painting it with a reddish tone; what made you decide this?"

Franquet interrupts and answers:

67

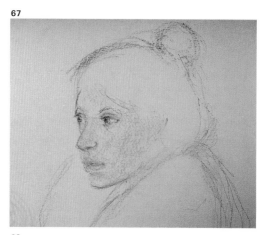

68

69

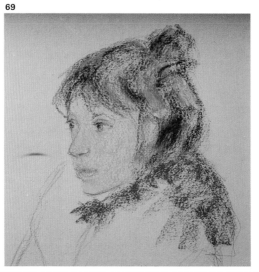

Figs. 67 to 69. First she concentrates on the face and head. In a portrait or figure painting, the head and face are the most important areas; they can give the painting a more perfect finish when the painting is completed. As Franquet says, "If I see that the head and face are okay, I feel more confident, I work with more enthusiasm." Notice how the color of the hair was obtained, first with English red and then, without stumping, a dark burnt umber.

"You see, because I'm interpreting, it's possible that in the end the hair color won't be the same as that of the model, it will be what I have imagined, what I want it to be."

Franquet continues painting and I observe yet another surprise: She is now painting the fur stole and black of the jacket with charcoal (figs. 70 and 71).

"Why? Why don't you paint it with black pastel instead?"

Franquet replies with confidence:

"When I have to paint in black, I usually use charcoal as a coat or background before using black pastel. Why? Because the charcoal provides me with a dark base, and after applying black pastel to it, I obtain an intense black; I would call it a velvety ef-

fect that gives greater contrast with the other colors."

And then she continues drawing with enviable ease, applying risky strokes with her charcoal.

"Drawing is difficult," she tells us, "but when you do it regularly, as an obligatory painting exercise, it becomes relatively easy."

As she gets to the end of this stage, Franquet picks up a light purple, and with uncontrollable fervor, she commences with the background, painting it a pinkish color that corresponds to the general color of the studio.

Fig. 71. This is the result after the second stage. You can see the confidence and perfection of the drawing as well as the quality of this first general color application.

70

71

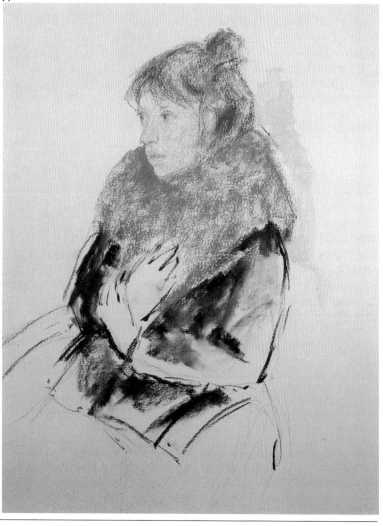

Fig. 70. Franquet continues painting and defines the black and dark areas, using charcoal instead of black pastel. "It's only the first coat," says Franquet,

"I will later reinforce these areas with black pastel and other dark colors. In this way, I will obtain a more intense black, which I prefer."

Third stage: firming up the drawing and the color

72

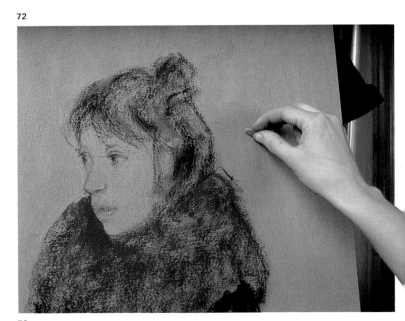

From the different stages, you have been able to see, through step-by-step photographs, how Mary Franquet draws and paints with pastel. This progressive format reminds me of something that Ingres, the great portrait painter of the nineteenth century, told his students: "You must paint your pictures from start to finish in a way that allows you to show them to the public at any given moment, whether as an initial well-thought-out plan, as an advanced sketch, or as a completed picture."

But Mary Franquet's most notable painting characteristics are the way her tones and colors vibrate, and the quality of the premeditated shades. The spontaneity of her drawn visible lines with hardly any stumping demonstrate the patience and sensitivity she applies in her work.

Now she is painting in light purple with wide strokes (fig. 72); she immediately returns to the body, applying a series of irregular strokes of gray, and then uses violet in certain areas over the previously painted first coat of charcoal in order to imitate the fur's texture. Then she continues on to the material of the jacket in the same way. She works in a continual manner with the charcoal—accentuating, drawing in contrasts, modeling forms. Next, she is thinking about the effect of *the law of simultaneous contrasts:* "A white will seem whiter when a dark color surrounds it." With that in mind, she paints, or rather sketches, the hands in white, and darkens a little more the black of the dress. In figure 74, you see the state of the painting at the end of this stage.

Fig. 72. Here, Franquet works on the background. With wide strokes she paints the entire surface in light purple.

73

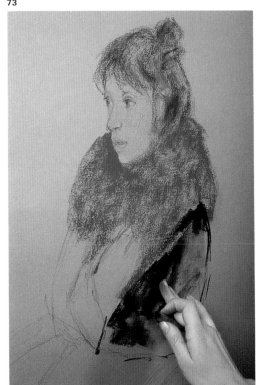

Fig. 73. In this state, you can see how Franquet applies the charcoal to darken and blacken the corresponding parts of the dress.

74

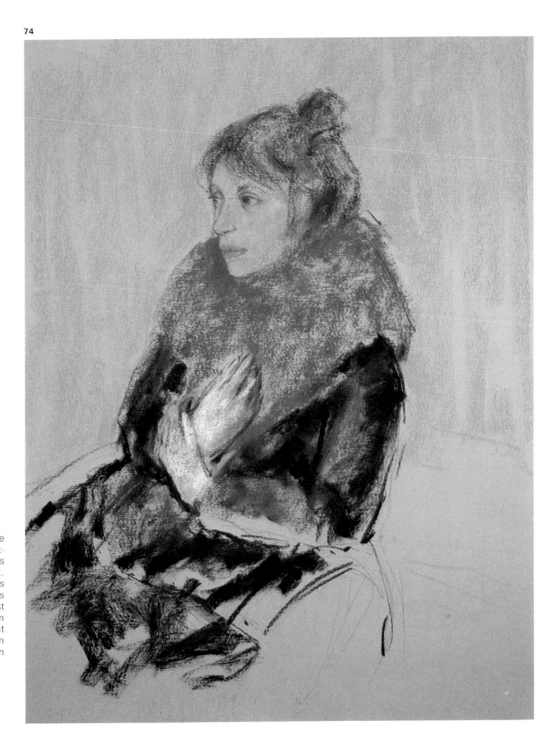

Fig. 74. By reviewing the various stages of this painting, you can see its progressive development. Also remember Ingres's advice to his students when he said: ''You must paint your pictures from start to finish in a way that allows you to show them to the public at any given moment.''

Fourth stage: head and features

Franquet is now concentrating on the form and color of the head. First, she styles and underlines the forms of the eyes, eyelids, eyelashes, and finally the whites and the shine of the eyes. In order to work out the form and color of these small details, Franquet paints with small touches and strokes, which are immediately blended with the tips of her fingers, using soft touches. Next, she reinforces the color of the face, using orangy, pinkish flesh colors (figs. 75 and 76). Then she stops, leaves her work, puts her pastels down on the table, and observes, all the time looking back and forth between the model and her painting.

Now she is looking for something. She looks at the table, around the boxes of pastels, behind the easel, and she finds it: a small mirror, which she holds in front of the picture, at head-height, at a 45° angle. By looking through the mirror at her work in this manner, she will be able to see any defects in proportion, construction, or dimension (fig. 77).

You may already know this simple trick of checking and controlling defects in the composition—an eye placed too high or low in relationship to the other eye, one side of the face narrower or wider than the other side, badly aligned eyebrows, a badly situated or disproportionate mouth, and so on. The mirror method goes back a long time. In the fifteenth century, the artist Leone Battista Alberti wrote in his 1436 treatise *Della Pintura:* "A mirror will help you greatly to judge the effect of relief. And I do not know why it is that when reflected, good paintings are full of charm. It is absolutely marvelous how the mirror can bring out the ugliness of any defect that there might be. That is why paintings of faces must be corrected with a mirror."

"Does the likeness worry you?" I ask Franquet.

"No, I'm not painting a portrait, although when a head is drawn or painted, if the proportions and construction are perfect, a likeness is inevitable; you do not have to look for it, it is found. Clearly then, one can interpret, correct, and idealize, just

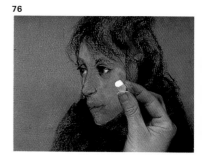

as the classical Greek painters did when they painted their Venuses and Apollos. But I'm not looking for a likeness; I concentrate on the construction, on a picture well done."

Finally, now that Franquet is satisfied with her "likeness," she works on the color of the face, perfects the form and color of the hair, and thus arrives at the advanced stage that you can see in figure 79.

Franquet puts down her colors and turns around to face us, smiling: "That's it. I'll continue tomorrow. I want to leave it for a while, until tomorrow, so I can see better what is lacking and what is not needed."

Figs. 75 to 77. The head, face, and features, structure, dimensions, and proportions must all be correct: one eye in relationship to the other eye, as well as the nose, the mouth, and the chin. Franquet is well aware that in the face, for example, there cannot be any errors in placement or proportion. She uses the old method of checking a painting through its reflection in a mirror, in order to look for possible errors.

79

78

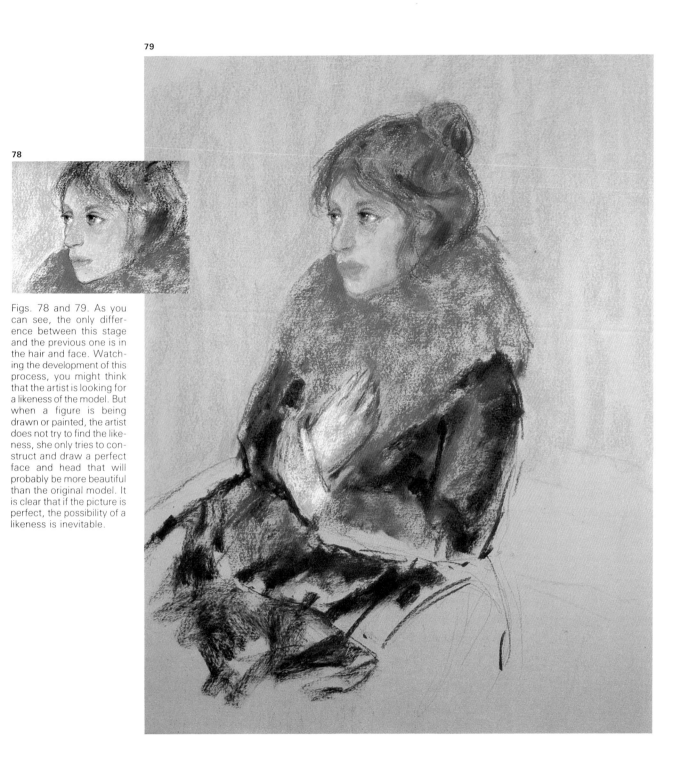

Figs. 78 and 79. As you can see, the only difference between this stage and the previous one is in the hair and face. Watching the development of this process, you might think that the artist is looking for a likeness of the model. But when a figure is being drawn or painted, the artist does not try to find the likeness, she only tries to construct and draw a perfect face and head that will probably be more beautiful than the original model. It is clear that if the picture is perfect, the possibility of a likeness is inevitable.

Fifth and final stage: finishing touches

80

81

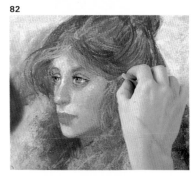

82

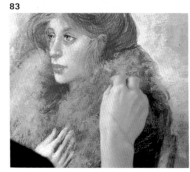

83

Figs. 80 to 83. You see the basic finished picture in this photograph (fig. 80). From one day to the next, when Franquet was alone with the model, she took the painting to near completion. She then redrew and repainted some of the features of the face, hair, and fur stole, and finished it by saying, "I think that's it."

We had arranged to meet Franquet at ten o'clock the next morning. When we arrive at her studio, we find that the painting is practically finished (fig. 80); Franquet is working on the finishing touches.

She excuses herself, and continues painting while saying: "Yesterday when you left, I stayed with Montse, the model, and really felt like going on and painting the small details. I became so enthusiastic that I practically finished the picture."

Montse arrives, sits down, looks at Franquet, and surprisingly, remembers the exact same pose as yesterday.

Franquet ties up the last details, accentuating and rectifying the color and form of the lips; then she draws and paints the light and shadow areas of the hair. Once again she constructs and paints the form, texture, and color of the fur that the model is wearing. And...

"I think that's it," she says, and adds, "but I'd like to leave it and look it over tomorrow or the day after. You know, there is always the possibility of changing or improving something."

The next day Mary phones me:

"I took that shadow out, the one behind the head on the left. Remember...? I had painted it with the idea of highlighting the head. But it didn't do anything, it only complicated things. So I took it out. Anyway... I've touched up one or two other things, the arms of the chair, the gray-colored fur, that blessed fur! But that doesn't change anything... okay? You can tell the photographer to stop by and do another photograph."

Here is Mary Franquet's finished piece.

84

Fig. 84. But the next day... Well, I must say that it is perfectly normal that a professional artist reconsiders her work after saying it is finished, and thus continues to paint— touching up details, shapes, shades... Mary Franquet reconsidered some things at the last moment, she left many things as they were, and redid others. In particular, she changed the color of the dark background shadow to the left of the head to the same color as the rest of the background.

With the painting finally finished, you can see a mixed style in which certain stumped zones are combined or superimposed with visible drawn lines, creating a mixed technique of drawing and painting.

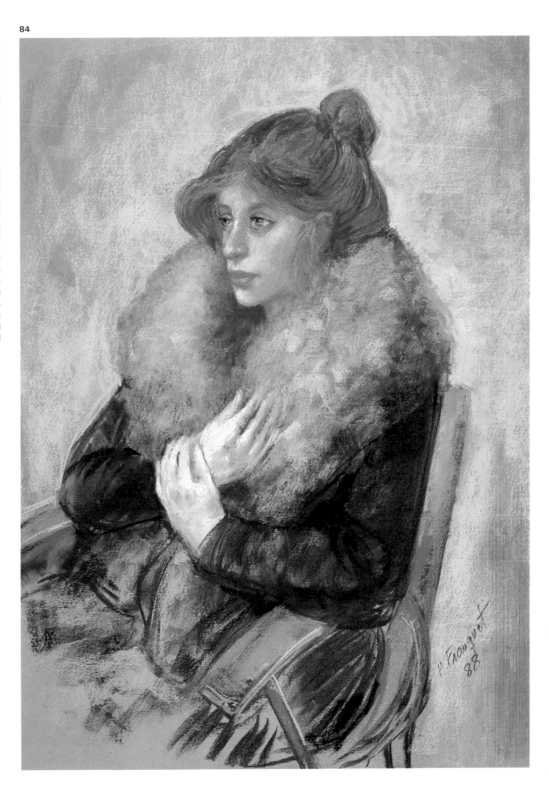

Oil and pastel

85

Joan Martí studied fine arts in Barcelona, where he was born. He received several scholarships and continued his art studies in Italy and then in Paris. Martí finished his art studies in the United States.

In 1963, Martí had his first exhibition, and since then has been exhibiting throughout Spain and in Paris, Caracas, Washington, New York, and Luxembourg. He has received the van Gogh drawing prize among many other awards.

Martí's studio is in a high part of the city, facing the south. The south side of the building where the studio is located is entirely made up of windows, through which the artist receives direct sunlight. "But the best painting light comes from the north," says the painter.

Pastel vs. oil

Martí frequently paints in oil as well as in pastel. He is going to paint a pastel picture for us, but first he begins by telling us the differences between the two mediums. "To begin," the artist says, "pastel tends to be a faster method of painting; oils are more laborious. Pastel allows you to begin and finish a picture in a single session. Oil, on the other hand, generally needs several days for drying."

In general, when he paints in oil, Martí works on several paintings at the same time. As you can see in his studio, there are a number of unfinished paintings.

"If you talk about the color," Martí continues, "I don't see why there should be any difference between pastel and oil. Of course, every painting needs its own special treatment of colors, but it has nothing to do with whether one uses oil or pastel."

Fig. 85. Joan Martí was born in Barcelona in 1936. As in the case of most painters, he has not limited himself to one technique. The artist has painted many themes in a wide variety of mediums but he prefers the portrait and figure, and working with oil and pastel.

Fig. 86 and 87. As the photographs show, Martí has many easels at his disposal. His studio is large and well illuminated by windows that take up one of the walls.

Figs. 88 to 91. On page 39 you can see examples of Martí's paintings. Note the different finishes that can be achieved with pastels: visible strokes, blended color, or a mixture of the two.

86

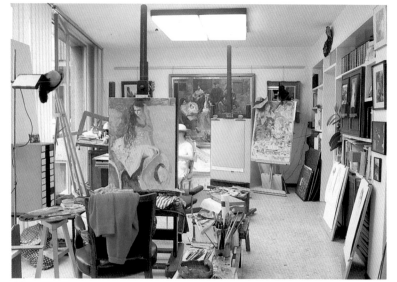

87

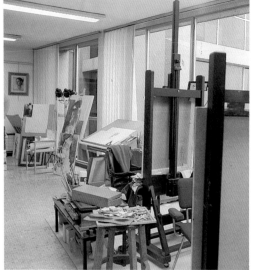

The work of Joan Martí

88

89

90

91

Model or photograph

Martí, who has painted many portraits and figures, is accustomed to working from models. But he also paints from photographs. In this section, he discusses the differences between the two methods.

"There are painters who you can tell have painted from photographs because they don't know the essential difference between a photograph and a painting. The contact between reality and painting is more direct with the model in front of you, but at the same time, among other things, it is easy to get confused with the model."

The photograph, of which Martí is an aficionado, is a great help to him: "And it has been this way for many artists, including the impressionists as well as Joaquín Sorolla and other famous painters. The painter can use a photograph, but that's not to say he should do without a model. Sometimes the model helps with difficult poses or complicated compositions."

In regard to dress, Martí says he often improvises. Today it is a white dress with lace and a broad straw hat with a red band. "I like to improvise the pose as well. The more you paint, the more difficult it is to find poses you haven't used on previous occasions."

The model for today's session is the painter's wife, quite a common subject with painters.

If the pose is not fatiguing, the model can maintain it for a few hours. But if it is difficult, "then it's time," Martí says, "for the help of the photograph. Once the initial sketch of the pose has been drawn, it can be photographed and used to work from."

Martí thinks that when a female figure is the subject of a painting, any decoration is secondary. On the other hand, when the figure or subject matter is integrated into what you might call a narrative or atmosphere, then the decoration, as a whole, takes on greater importance.

92

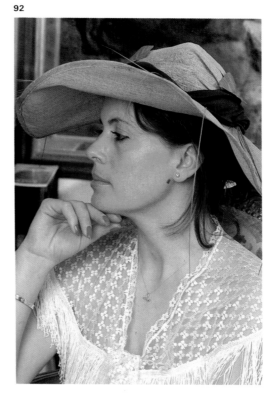

Fig. 92. Martí is going to paint a figure. He is not attempting to achieve a likeness as would be the case of a portrait painter. The figure painter finds a pose that ''explains'' his interpretation of the theme. After suggesting several poses to the model, Martí chooses the one you see in the photograph. He has chosen a composition that is almost without background in order to give the woman's head, seen in a profile with her chin resting on her hand, ''the leading role.''

93

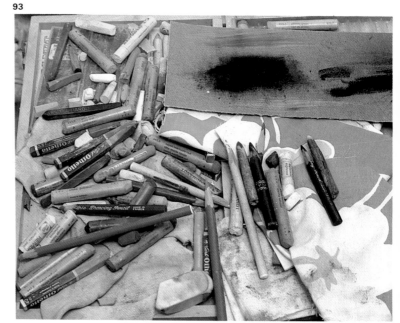

Fig. 93. In Martí's pencil box, apart from the pastel sticks, there are pastel pencils, which the artist uses to draw defined lines. He uses sandpaper to keep his pencils sharp.

First stage: the charcoal sketch

Figs. 94 and 95. Martí starts to construct the picture with charcoal. He does it quickly and confidently, not only profiling the head, but also drawing in the detail of the hand.

Fig. 96. The present state of the drawing is meticulous. Martí believes that by doing a drawing with a good finish, he will be able to apply color without problems. He has not only boxed and proportioned the drawing, but has also emphasized some shadows on the cheek and neck.

The painter starts by looking at his model. He decides to change the straw hat for another one that is darker, more flexible, and with a violet band instead of a red one. Martí asks his model to change hands, and she does so with the expertise of someone who is accustomed to interpreting the painter's designs. He gets up, rearranges her hair a little, places her head in more of a profile position, and then he sits down again.

Placing charcoal to paper, Martí is ready to begin. He has attached the paper with pins to a drawing board. The paper is beige-gray. "I never start with white; the problems of color harmonization are easier to solve when you start off with a neutral tone." He starts sketching with the charcoal. He goes about it quickly and with confidence, but even from the beginning, he sketches the features with great care.

Sometimes he draws a very fine feature line, which he immediately blends in with his finger. Then he draws in some light shadows on the face and does not hesitate to fill in the hair and hat band with black.

Afterwards, he outlines the hand under the chin. Martí is progressing with his drawing with great care. At the end of this stage, the forms, the pose, as well as the shadows of the figure have been defined.

The painter allows the model to rest while he continues to look at his work. He applies a light coat of fixative, which will stop the general charcoal lines from fading when he starts to paint with pastel.

94

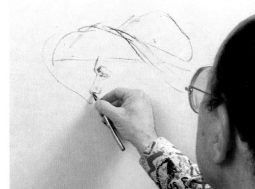

95

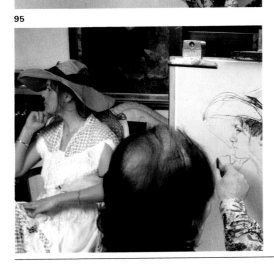

96

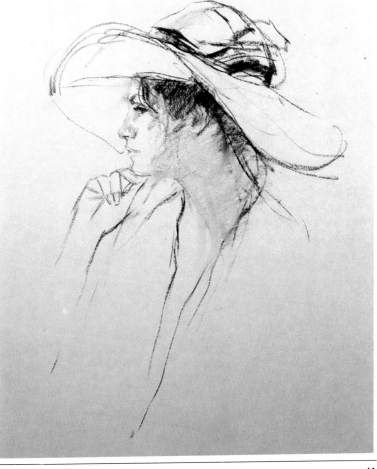

Second stage: outlines and shadows

97

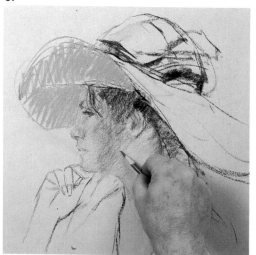

Martí starts to fill in the face using an umber tone pencil. With the same pencil, he works in the light and shadow zone. "It's a question," observes Martí, "of the sensitivity of the hand, of putting more or less pressure on the pencil when passing it from one zone to another. It's not dogma, I do it that way to get good results, but someone else might do it in a totally different way."

Fig. 97. Martí begins applying color with a well-sharpened burnt umber pastel pencil, with which he fills in the model's face and the hat.

Figs. 98 and 99. He paints the hat band in green, and sketches the strands that hang from the band with the same green. Then with a pink pastel pencil, he starts to give tonal value to the cheekbone.

Martí explains the difference in skin tone between the model's face and neck. The face is browner because of its exposure to the sun while the neck area tends to be bluish in tone. With that in mind, he works each of the zones with different mixtures: sienna and green in the shaded area of the face and upper neck, and pink with a touch of blue in the lower neck.

Now and then Martí stops and thinks about how he will proceed. These pauses are brief, and he almost immediately returns to his work.

98

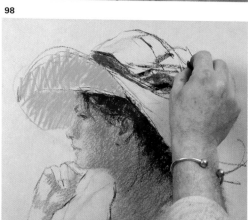

He quickly fills the illuminated area of the hat with white. For the hat band, he uses an olive green. Now he starts to work on the white dress. "Painting," he says "is a mystery, you never know how things will turn out. But in any case, some background knowledge is necessary; painting shouldn't be taken for granted."

Using precise sienna lines, Martí sketches the shadow zones of the hat. The pink he has used in the lower neck gives the cheek a slight warm shadow. With a greenish brown, he sketches the principal shadows on the hand.

Then he stops, telling the model that she can rest.

99

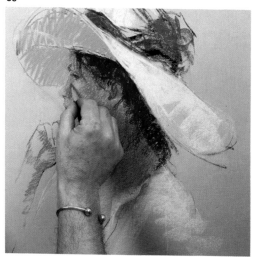

100

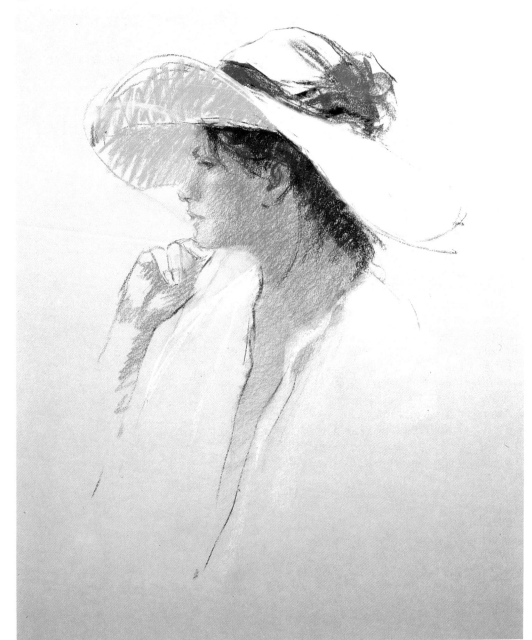

Fig. 100. As you can see in the photograph, there are many differences between the previous stage and this one. Here, you can see that Martí has painted in what will be the definitive colors of the painting. (The painter shows his facility of interpreting color harmony in the initial stage of a picture.) Notice how the lines of the pastel pencil in the brim of the hat remain visible, while Martí has blended the lines of color in the cheek to give it a tonal value. He has also created shadows and applied highlights in the corner of the mouth and in the profile of the nose. Using green burnt umber, he has painted the shadows of the hand, to which he has started to give volume. Finally, he has applied white to the brim of the hat and to the dress, which occupies a large area of the lower half of the painting.

Third stage: constructing the face using fingers

Martí returns to what he calls the "combat position" in the painter's fight against reality. "Ideally it would be nice to convert the enemy into an accomplice," says Martí.

The painter explains that while he was doing the initial sketch in charcoal, he had the general idea of the color harmonization in his head: "Although," he adds, "sometimes what is in your head coincides with the final result and sometimes it doesn't. It is better like that, otherwise painting would be extremely boring."

Now that the colors of the face, upper neck, and lower neck have been applied, the painter starts stumping the pastel with his fingers, leaving some of the outlines visible.

He works carefully on the ear and eyebrow. Applying the color with a halved pastel stick at an angle, Martí alternates the stumping with strokes and comments, "Sometimes I use a cloth or stumping pencils or anything I can."

Every so often he looks into his pastel box, as if he were deciding which pastel to use or doubting if the one he is looking for is there.

Martí alternates between the light and dark tones, working the upper part of the face without haste or pauses, creating daring highlights, such as the clear white point on the tip of the nose.

Now Martí practically blurs the mouth area (which had been carefully sketched with charcoal) by stumping it. He goes back to the eye and applies blue pastel over the eyelid.

He goes over the eyelid in black and uses the same black to reconstruct the eyelashes. Returning to the mouth, which is practically erased, Martí reconstructs it with sienna.

With the same sienna, he reworks the cheek then takes a pink and establishes a light zone between the lower eyelid and the cheek.

He pauses and cleans his fingers. Alternating between the burnt sienna and the pink, Martí works on the lips. He draws in the pink gleam of the lipstick, the model's only makeup.

101
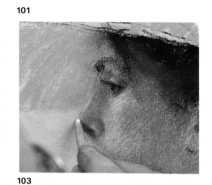

102

103
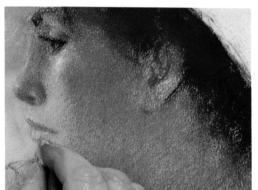

104
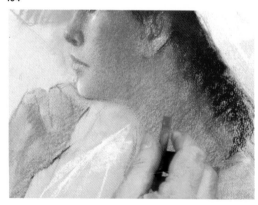

Figs. 101 to 104. In these photographs you witness Martí's way of working. He alternates the colors in the face, not only touching up the mouth—which he had drawn in with charcoal and painted in with shadows —but also applying highlights to the nose with a white pastel pencil.

After this, he brightens the forehead with pink and immediately darkens the neck using burnt umber. He goes back to areas already worked—redoing, touching up, and elaborating.

The head has developed imperceptibly in this stage, acquiring volume and relief. For the first time since Martí began applying colors, he stops, at the chin.

105

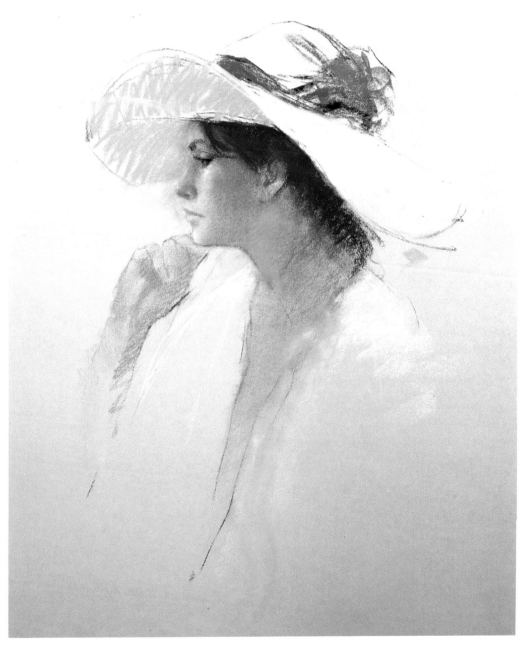

Fig. 105. If you compare this stage of the painting with the previous stage (fig. 100), you will see that the differences are subtle, but important. The differences can all be found in the face and hand, where Martí has continued to work in order to obtain the flesh color shades. The rest of the painting has not been worked on. Martí has blended the colors along the profile area with pastel pencils in order to obtain very concrete highlights and details.

Outlining the chin in pink, he *closes off* the light zone that he has just established. He closes off that area with burnt umber, which he softens with his fingers.

With a careful motion, he uses the burnt umber to draw the line of the neck.

Martí now begins to use pink in the shadow zones, giving them more light. It is important to emphasize that in shadows there is light and in light there are shadows. This is something Martí knows very well, and puts into practice.

Fourth stage: redoing a hand

The main focus, the expression of the face, has been completed according to the painter's interpretation. Now he needs to work on the rest of the painting, reinforcing what the artist deems essential in the picture: "It's well under way, but the hand has not been finished."

But Martí does not go directly to the hand. For the initial step in this fourth stage, Martí starts to stump areas of the hair and hat that are still only defined by strokes. Now you will see areas of lines totally replaced by stumping. "I'm not dogmatic," the painter says of his eclectic approach. "No soft stumping and no hard lines either. The treatment produces the theme. The painter should regard the theme in a way that it itself imposes the outcome." Martí continues to explain, "In a sketch of a popular cafe singer my lines would be energetically drawn, they would be visible lines. In a male figure painting, the features must also be given vigorous treatment. On the other hand, in a painting of a woman such as this painting, a delicate treatment is required; this should not only be in concept, but it must also be in the technical execution."

Martí reworks the hat again, which he has already blended with his fingers using pink in the light zones and sienna in the shadows. Then he stops his work, goes over to the model, and moves her hand in an attempt to put it into its original position. The model gets up to look at the picture in order to remember the initial position. This may happen quite frequently, because the painter will adapt the painting to what he views as a closer reality. Martí erases the lines of the first position and redraws it as he sees it now. Since people and animals control their own movements, they cannot be manipulated in the same way as objects, such as a vase. "And it is not the same to move some apples in a still life as it is to move someone's fingers. That is where still life gets its name," Martí explains.

Now back to the fingers. While he applies red with his fingers to the hand areas, Martí comments that he has painted more figures than landscapes, but not because landscapes do not interest him, it is only because people ask him for more of the former.

Fig. 106. Martí now paints the light part of the hat's brim in pink, an area he had earlier painted in white.

Fig. 107. Probably the most definitive characteristic of pastel is the possibility of obtaining chiaroscuros by blending colors. In this example, you can see Martí working on the light areas of the hand.

106

107

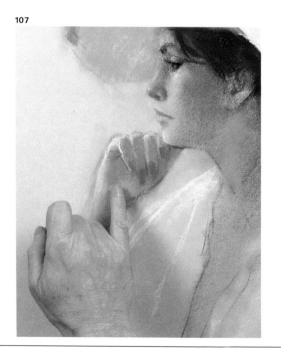

108

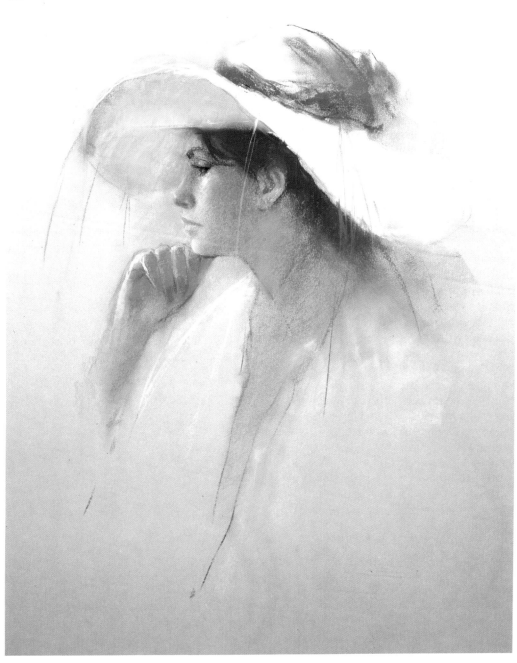

Fig. 108. Fig. 108. In this stage, Martí has blended the only zone of the painting that still has visible lines: the brim of the hat. And in order to achieve volume in the hand, which he redrew, he has blended the area with a piece of pastel, which he can erase with a cloth and paint on top immediately.

Having said that, Martí finishes the hand. He has reconstructed and colored it with burnt umber, ochre, and carmine with vermilion. The light zone is established with the pink of the hand blended with the color of the fingers. Using the same color pink, he reworks the light zones of the face.

In order to tone the light zones as well as the shadow areas, he uses a mauve. With fine touches, Martí marks the strands of straw that stick out of the hat band and hang over the brim of the hat.

Fifth and last stage: a vaporous finish

109

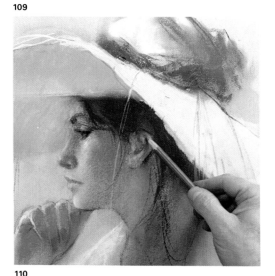

Martí continues working after a brief pause, adding precise touches, some of which he does not blend with his fingers. It is the beginning of the end. He indicates the light parts with a dark mauve and a pure white.

In the central zone, the lower neck line, Martí introduces a light pink that he blends; under the ear, he blends in a dark green. With the same green, he partially redraws the ear and draws in a freckle that the model has under her earlobe. Even though he said at the beginning that he didn't want to paint a portrait, Martí decides not to omit this small detail.

"But that doesn't mean I detach myself totally from reality. Reality is only the inspiration. I put what I want of her in the picture, and what I want to change, I do."

For example, the artist has adjusted the real color of the hat. He has slowly changed it throughout the session, preferring to work with lighter tonalities, in a pink range, which differs from the straw color tone of the original hat.

He spreads a subtle gray between the light brim area of the hat and the model's left shoulder, which is on the right side of the picture. Using the same gray, he draws one precise stroke to profile the arm. Then he reinforces the arm with umber and ochre, the same color ochre he used for the shadow relief of the hat and for the lower neck area of the dress.

"Pastel should be free and vaporous. It should look like something unfinished. If the result looks very finished, it could look like a characterless painting. In some ways, it's all about leaving the painting at a point in which the spectator can participate and use his imagination."

And to demonstrate that he is satisfied with the state of the painting, Martí signs and fixes it: "So that it doesn't lose its tone," he indicates, "because pastel loses its tone if it's not fixed right away."

110

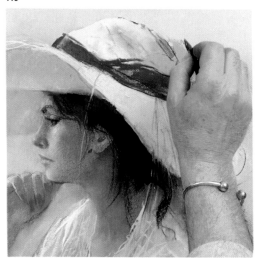

111

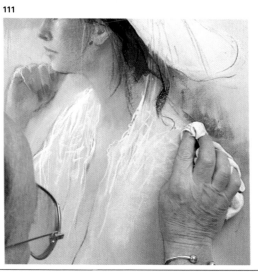

Figs. 109 to 111. Martí now paints in the very concrete details. With a pastel pencil, he reconstructs the ear (fig. 109) and uses a light green to paint the loose strands of the hat band (fig. 110). And even though Martí wants to leave visible lines, he continues blending colors. With a cloth, because it is more practical than fingers for wide zones, he continues to blend the contours of the dress. .

Fig. 112. Now compare the previous stage (fig. 108) with this finished painting. Martí has worked out all the details, but, as you can see, the differences are sensitive, thanks to the specific highlights. Marti has also blended in a light pink in the lower neck area, reinforced the dress area with white, and emphasized the line of the dress to create a vibrancy in the central zone of the picture. With respect to highlighting specific areas, Martí has painted a gray background under the illuminated part of the hat's brim, and with the same gray, has reinforced the contours of the arm. These "touches"—accentuating highlights and shadows— have added a free and vaporous finish to the painting. Martí chooses this style, because he does not like laminated finishes.

112

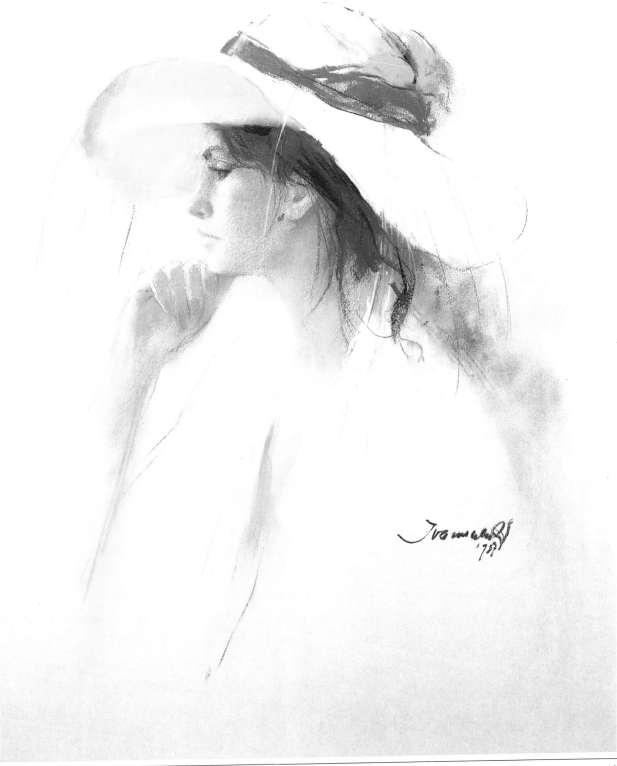

A theme, a technique

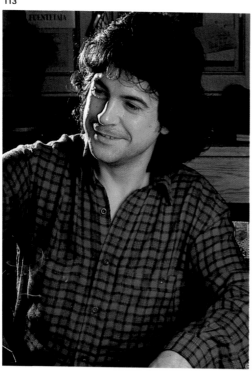

José Luis Fuentetaja was born in Madrid in 1951. In Madrid, he studied fine arts at a trade school (where he developed his innate drawing ability), and later attended the Fine Arts Academy.

Fuentetaja enhanced his art studies with a scholarship to Rome and went on to live for long periods of time in other European cities. During this period, he acquired solid artistic experience, painting colorful and inexhaustible varieties of personalities: from the old *clochards* on the streets of Paris to the hippie families in Amsterdam.

Many of Fuentetaja's paintings are grouped into different series of works based on specific themes, such as his tramp series. Because his paintings have evolved into a variety of themes and techniques, I ask Fuentetaja, who has painted a lot in oil, why he is now painting in pastel and if he uses both techniques at the same time.

"No, I've never painted in oil and pastel at the same time. My paintings are grouped into thematic series such as tramps, children, female nudes ... and they are all painted with a specific technique, because I believe that theme and technique are intimately related. That doesn't mean to say, of course, that I paint all nudes with oil in the same way. They are all different *nudes*. And that is, for me, a fascinating challenge that all painters have to confront: *exhausting* the expressive possibilities in each technique."

Fuentetaja's studio is located on the top floor of a house that he owns, in a tourist town on the Spanish Mediterranean coast. An interior wooden staircase connects the living quarters with the studio. It is about 19½ × 10′ (6 × 3 m), and a large portion of the roof is paneled in glass.

Fig. 113. José Luis Fuentetaja has painted and drawn in oil and watercolor, but nowadays he paints almost exclusively in pastel. No matter what technique he chooses, Fuentetaja searches for different, expressive possibilities.

Figs. 114 and 115. Fuentetaja's studio is in a house he owns, which is separated from the living quarters—the dream of many painters. Natural daylight illuminates the studio by way of light shafts in the roof. He says that he often paints at night with artificial light. On his sideboard (fig. 115), you can see his art books and stereo—music is a good companion for the painter.

Posing the model: composition

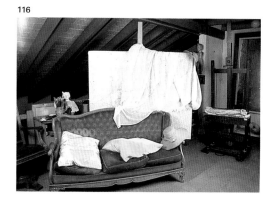

Fig. 116. Atmosphere is a fundamental factor in figure painting. With this selection of objects—the "decadent" style of the sofa, the colors of the cushions, the hat, the creased fabric hanging over the backrest of the sofa—Fuentetaja is not only creating an atmosphere, he is also harmonizing the colors from the start.

Figs. 117 and 118. In creating the scenery, Fuentetaja will harmonize the colors using a variety of objects. While he chooses the model's pose, he is composing the picture.

Fuentetaja has almost exclusively painted portraits and figures. When he paints landscapes, they are urban landscapes that are a part of the atmosphere that surround *his* subjects.

"In the beginning, I painted many portraits that were commissioned," he explains. "In the portrait, the most important thing is the face of the person you are painting, the aim is to achieve a likeness. Everything else is simply an accessory. In figure painting on the other hand, the pose and the composition are important because they help create the sensations that the model inspires for the artist."

So for Fuentetaja, the choice of pose and composition are the main factors in the painting process. When he is composing, Fuentetaja is painting.

In fact, he will do that now.

The model is sitting on the sofa with her back toward the artist. There are two cushions and a straw hat next to her, which Fuentetaja sees as color areas in the picture.

Behind the sofa, Fuentetaja has placed a white piece of material. But even before starting, he decides to change it. He prefers the background color to be in harmony with the color range that the theme requires. He hangs a piece of pink satin material over the white sheet.

Then he takes the hat and places it on the backrest of the sofa, on the right-hand side of the composition. Now he will talk about composition.

"Very often," he explains, "I employ a triangular scheme in my paintings. This type of scheme is present in this picture as well; but moreover I have incorporated two centers of interest: the cushion on the left, and the hat I've just placed on the right, which will compensate for the figure on the left-hand side."

Ingres, the famous French portrait painter of the eighteenth century, once said: "Beautiful forms are those that do not endanger the effect of the principal forms of the picture."

In choosing the model and the selection of objects, Fuentetaja is taking into account, perhaps unconsciously, Ingres's advice: He has chosen a composition that highlights the figure.

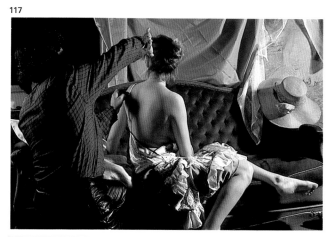

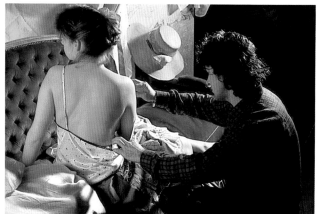

The work of Fuentetaja

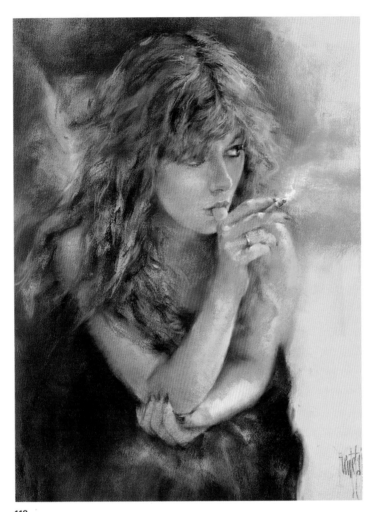

119

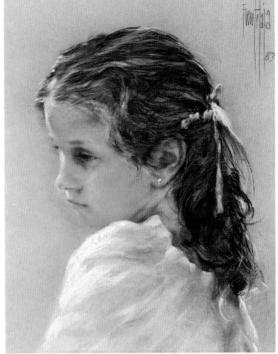

120

Figs. 119 to 123. You can see on this double-page spread some examples of Fuentetaja's work. He is a pastelist who knows how to use colors to achieve all kinds of finishes that pastel has to offer.

121

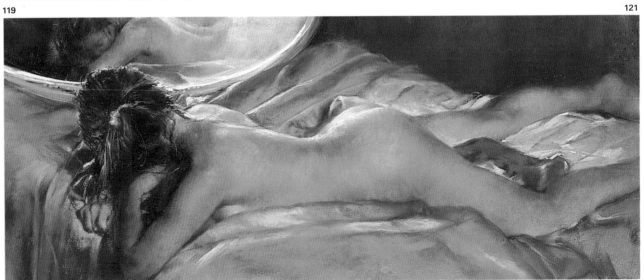

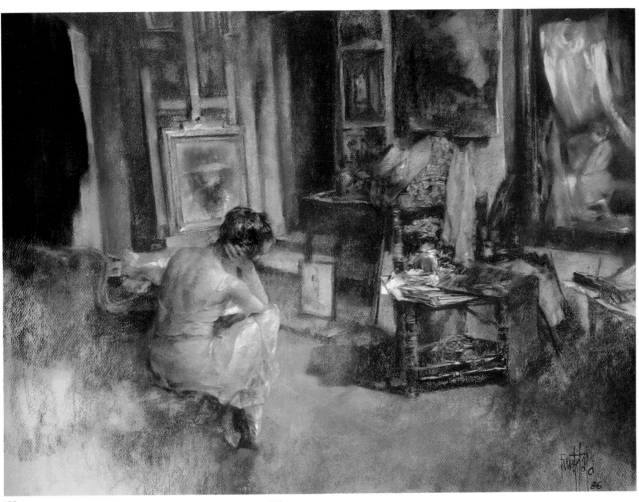

122

123

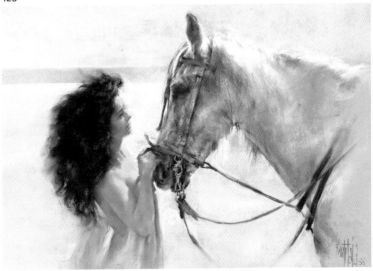

Analyzing his work would be, without doubt, a good exercise for anyone who is interested in painting in this medium. He demonstrates his versatility by creating paintings where the colors were obtained through blending, yielding results similar to oils (figs. 121 and 122), and paintings where the backgrounds are the very color of the paper and individual strokes remain visible (figs. 120 and 123). There is also a mixed technique painting (fig. 119), a combination of both methods. Fuentetaja is a master of pastel paintings; he can obtain the finish that each theme requires.

First stage: drawing and volume

In Fuentetaja's studio, there is a splendid piece of black furniture, with big drawers, inside of which you can see tubes of oils and boxes of pencils and pastels, all perfectly arranged.

The artist realizes that organization is important for painting. For this reason, he tries to overcome his inborn tendency of being disorganized and attempts to organize his tray situated under the easel, which contains the pencils and sticks that he is going to use.

"But since I generally paint with harmonious color ranges," Fuentetaja tells us, "I have no need to look for the colors in the tray because I keep the colors I'm using in my left hand."

He uses a $23 \times 19''$ (60×50 cm) sheet of medium gray Canson paper. As he attaches the paper to the easel with pins, he explains that using colored paper helps to avoid any problems with color harmonization from the start.

The same can be said of the paper grain. The paper used by pastelists has a different texture on each side: medium or hard grain. The pastel dust adheres to both grains in different degrees. So the choice is conditioned by the theme.

Fuentetaja is going to paint a semi-nude woman, a theme that requires a medium-grain paper for uniform stumping.

To begin, he starts drawing firm decisive sketch lines. He uses a well-sharpened piece of chalk that he then blends with his little finger and thumb. As the drawing develops, you can see that Fuentetaja is working on the volume simultaneously.

Next, he sketches the first shadows on the model's back and on one of her arms. For the moment, he does not use any color pastels. In order to highlight some shadows, Fuentetaja uses a Conté orange pencil, and, with the same pencil, he darkens the backrest area of the sofa closest to the model.

Fig. 124. This is the pose that Fuentetaja finally chooses. Notice how the figure integrates perfectly with the background through the placement and color of objects.

Fig. 125. The painter keeps his boxes of pastels all perfectly arranged in drawers. All painters should have something similar in their studios.

Fig. 126. Here is a tray that is situated under Fuentetaja's easel containing the pastel pencils and sticks that the artist has chosen to paint with. Like many pastelists, he does not use whole sticks, but prefers painting with stubs.

124

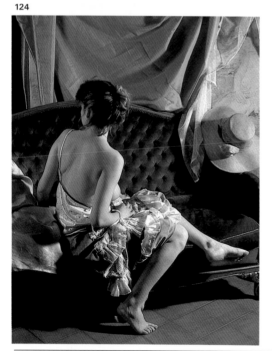

125

126

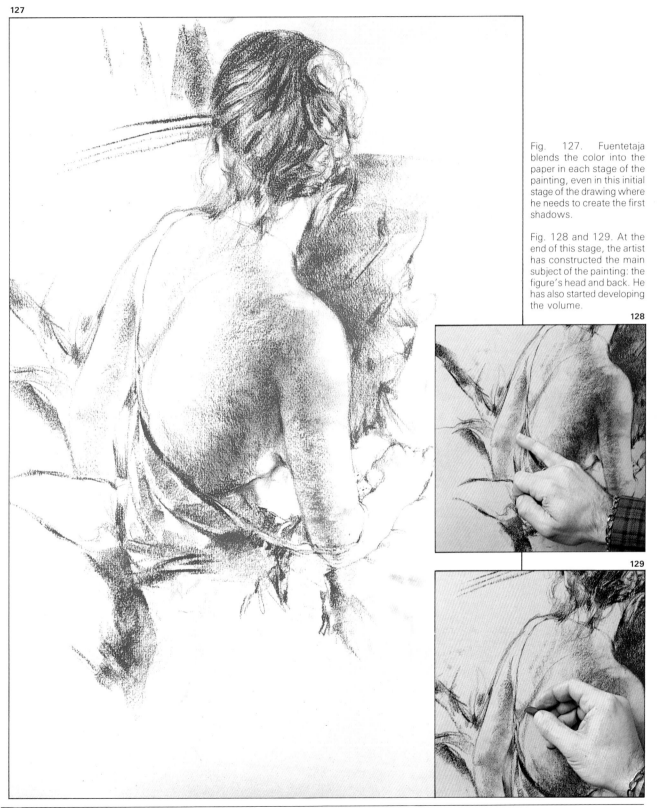

127

Fig. 127. Fuentetaja blends the color into the paper in each stage of the painting, even in this initial stage of the drawing where he needs to create the first shadows.

Fig. 128 and 129. At the end of this stage, the artist has constructed the main subject of the painting: the figure's head and back. He has also started developing the volume.

128

129

Second stage: color stains

Once the model's back and hair have been drawn—the main focus of the picture—Fuentetaja leans back in his chair and tells us about the experience that made him change his way of working.

"At one time, I used to draw, then paint, basically *destroying* the drawing by filling it with color. Now I construct and paint at the same time. But what's more important is that I do it over the whole surface of the picture."

As Ingres, the great portrait master, once said, "You have got *to go over* the whole painting in order to paint."

After a very brief pause, he continues *constructing* and drawing the figure—he works on the profiles and proportions. Fuentetaja is a believer in a very finished picture.

"Perhaps it's a defect of my academic training," he comments ironically, "but I prefer to draw a picture with as much detail as possible. This may be because the painter has a large part of the work done when he has finished boxing and proportioning the drawing.

Like many pastelists, Fuentetaja thinks that black dirties when painting in pastel. For this reason, he will only use black in this stage of the picture. In this painting, he is using a Koh-i-noor brand charcoal pencil to box and profile the figure and background, and to put the shadows in relief.

130

131

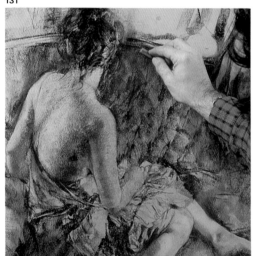

132

Fig. 130. Fuentetaja paints the model's back, arms, and legs using an orange Conté pencil, and thus obtains the first color harmonization of the skin color.

Fig. 131. Using the same orange Conté pencil, he paints the sofa's backrest. The background is then harmonized with the warm range he has chosen. He also highlights the figure's head.

Fig. 132. Fuentetaja wants to add some defined strokes into his pictorial language. In order to do this, he pauses to sharpen his pastel pencils and sticks with sandpaper.

Figs. 133 and 134. The second stage of this painting demostrates Fuentetaja's way of working. He is an artist who possesses a sound knowledge of drawing. Here, he constructs and paints with vigorous and decisive strokes simultaneously.

133

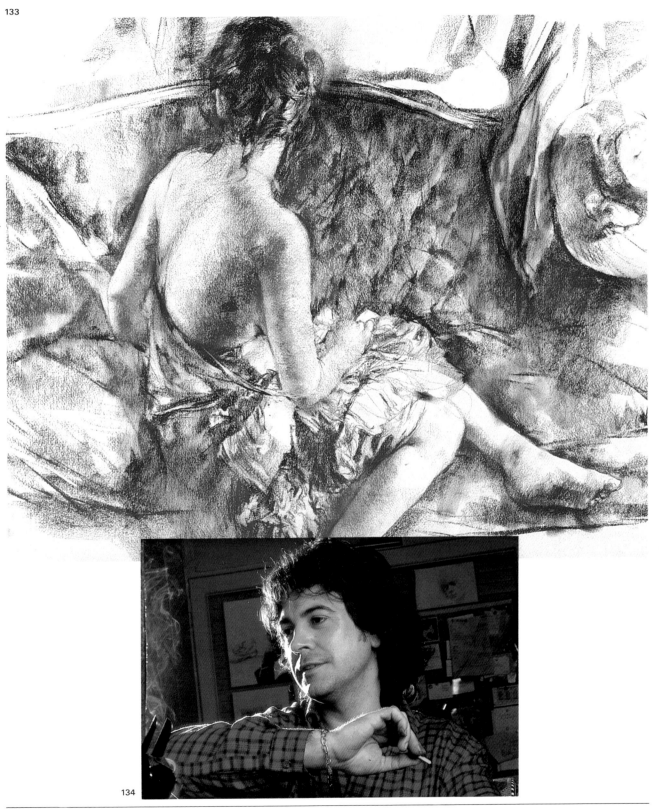

134

Third stage: pinks, ochres, reds... and blue

Fuentetaja now begins a stage of hectic activity, during which it will be difficult for me to keep up with his rapid and decisive way of painting.

He paints the hair with sienna, then blends it in with his fingers, and immediately after that makes a vigorous line in light ochre, in order to obtain a highlight.

"When painting in pastel you can superimpose light colors on dark ones," Fuentetaja explains. "It's the same with oil, but the more favorable advantage with pastel is that you can paint over dark colors immediately."

He blends the head's contour lines, applying color with a rapid hand movement, and thus obtains wisps of loose hair that dangle over the neck and ears.

"I think these loose hairs take the rigidity out of the head's contours. But also, I see them as a center of interest in the picture, counteracting the fact that the model is sitting with her back to us."

After the hair, he works on the back. This area becomes another one of Fuentetaja's obsessions in this stage of the picture. He paints the flesh with ochres, reds, and pinks. The figure has become more accentuated by the use of dark background colors, as well as being harmonized with the color range he is using for the painting.

As he works on the color harmonization, Fuentetaja introduces a color that at first might appear discordant: the blue of the dress. He uses the edge of the blue pastel to paint the shadows in the creases of the dress, which he then blends to obtain highlights.

135

136

137

Fig. 135. In this stage of the painting, Fuentetaja is trying to obtain a good blending with pastel, in order to achieve a soft pink tonality on the back.

Figs. 136 to 137. Fuentetaja introduces a cool color, the blue of the dress, to the painting's predominantly warm color harmonization. With only blue, he paints the dress's shadows, and then obtains lights with white (fig. 137). In this way, he accentuates the creases in order to achieve the fabric's texture.

Figs. 138 and 139. The artist has harmonized the painting with a range of warm colors: predominantly sepias, ochres, pinks, and so on. Notice how he has applied the colors over the entire painting surface, painting *everything* at the same time. By working in this manner, he has been able to visualize the painting's finish, and has toned the colors accordingly.

138

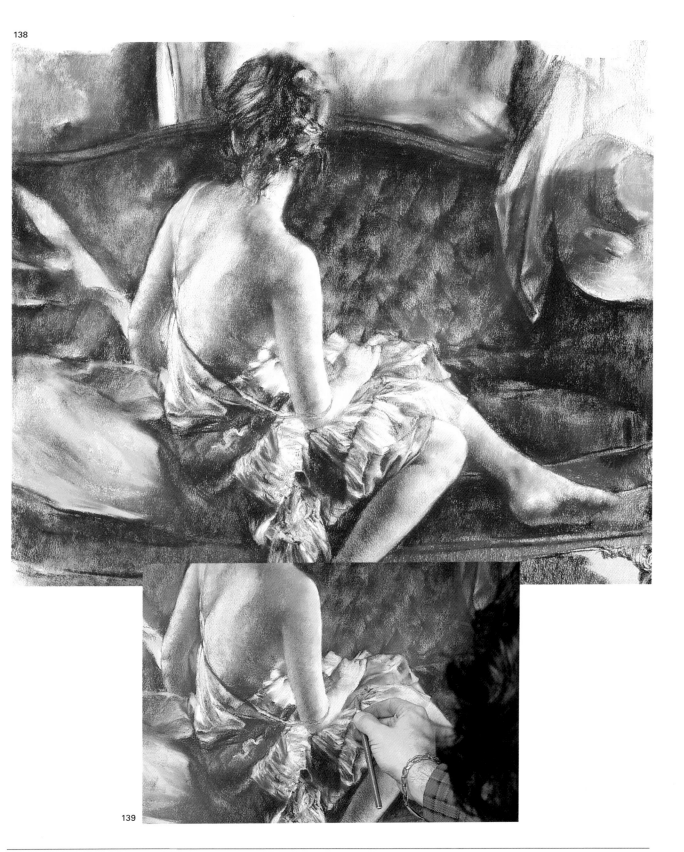

139

Fourth stage: darkening without black

Fuentetaja has filled the paper with color. He now takes a break in order to clean his fingers with paper towel. This is a precaution that all pastelists should take, because you can get to a point where all your fingers are stained with color and probably none of the colors are the ones you need at that moment.

The painter takes advantage of the break to tidy up his warm color range, because he is going to leave the blue for the moment. Furthermore, he is going to paint with hard pastel sticks and pencils in order to intensify the color.

Now he starts on the backrest of the sofa. But he doesn't use black, because he would run the risk of *graying* the picture. Instead, Fuentetaja uses sienna to darken the part of the sofa closest to the model. He paints with the edge of the pastel stick, drawing light strokes to create a corklike texture.

However, he does use white, though not for lightening the color, which would also turn the color gray, but as another color.

Fuentetaja paints one of the creases in the pink fabric backdrop in white. He has decided to change the real color, because he needs an intense light between the hat and the sofa's backrest, which will separate it from the background. This is a good example of the idea behind artistic *interpretation*, which makes each artist unique.

Fuentetaja paints the rest of the satin fabric, especially in the area closest to the woman's head, with the same pink that he used for the cushion in the foreground. This way he obtains a contrast between the head and the background.

He also darkens the color of the hair, and then paints visible lines in orange.

140

141

142

143

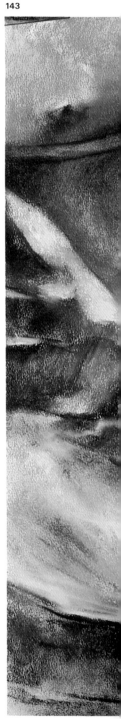

Figs. 140 and 141. Pastel allows you to create a wide range of finishes—which usually start from an intense blending with visible lines. Fuentetaja's painting is a mixed finish: blending to lighten colors, and painting visible lines with the sharp edge of a pastel stick to obtain highlights, as in fig. 141.

Fig. 142. With a paste[l] pencil, whose point i[s] harder than a stick, he ac[-] centuates the creases an[d] shadows of the dress.

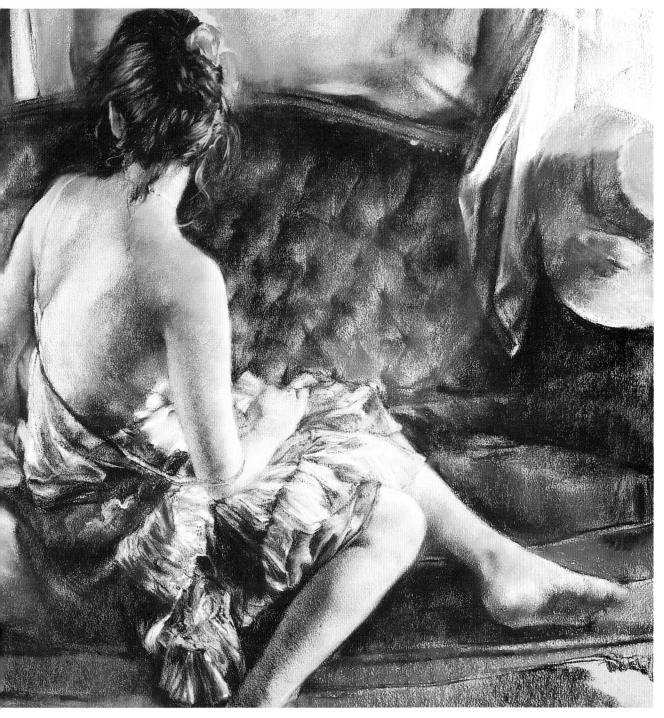

Fig. 143. Ending this stage, Fuentetaja has blended the figure's back to lighten the color in the light zones. Meanwhile, the visible lines in the hair darken the hair color. The general color intensification that Fuentetaja has carried out in this phase is important, because now the head accentuates the warm colors in the background.

Fifth and final stage: white is a color

As with all paintings, a pastel can be finished in a variety of ways. In fact, the finish in the previous stage could be one possibility.

But Fuentetaja prefers another finish for his picture. He wants to accentuate the lights and highlights, and intensify the harmony of the warm colors by darkening them.

That is why he returns to the blue. In the light zones, he blends in the blue to lighten the color, and in the shadow areas of the dress, he paints with dark ochre. What Fuentetaja is attempting to do in both cases is to make the blue less blue.

Then he paints the light zones of the dress in white. Applying a fine white line, he paints the shoulder straps. And with more thin white lines, he paints the highlights in the hat, satin backdrop, and cushions. In this way, he achieves luminosity in the background, and accentuates the light zones of the dress to highlight the figure.

Because Fuentetaja later plans to darken the color of the background with red carmine, he continues to work on some of the shadows that also contribute to the figure's importance—such as the backrest of the sofa closest to the hand, which gives the hand more volume.

For an instant, the painter rests his feverish creativity, which has taken him all over the painting surface—putting in a light here, a shadow there...

The pause, however, is very brief.

Fuentetaja begins to blend the colors in the woman's back by means of soft, uniform stumping that produces the subtlety needed for this theme.

But the artist does not persist too much. He is satisfied with the painting's finish.

José Luis Fuentetaja's figure painting is a fine example of how to use pastel colors to obtain a finish resembling an oil painting.

144

Fig. 144. This is the finished product of this magnificent pastelist, a work in which the proportions as well as the choice of composition are evidence of the artist's profound knowledge and experience in this field. In this painting, Fuentetaja has incorporated two characteristic methods of pastel painting: blending with fingers, which was used in the back and legs of the figure, and visible strokes or lines, used in the hair and background. By painting with these mixed methods, Fuentetaja has accentuated the expressive force of the theme. He has also clearly differentiated two planes: the background, composed of vigorous strokes, and the foreground, harmonized with the same color range, but where most of the color has been blended.

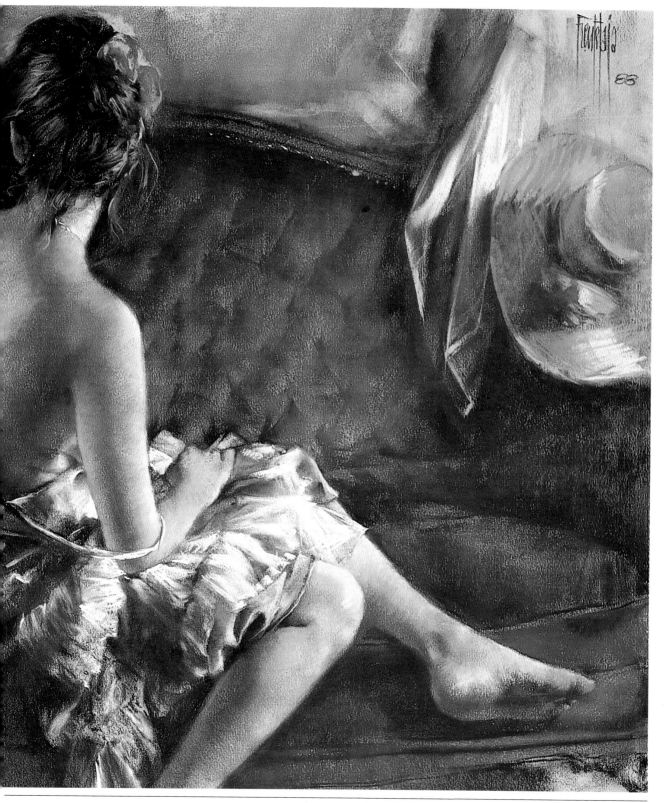

Contents